EDINBURGH
STREET FURNITURE

EDINBURGH
STREET FURNITURE

David Brandon

AMBERLEY

First published 2011

Amberley Publishing
The Hill, Stroud,
Gloucestershire, GL5 4EP

www.amberleybooks.com

British Library Cataloguing in Publication Data.
A catalogue record for this book is available from the British Library.

ISBN 978 1 84868 388 4

Typesetting and Origination by Amberley Publishing.
Printed in Great Britain.

CONTENTS

INTRODUCTION

Edinburgh is now, and indeed has long been, a city of stark juxtapositions and piquant contrasts. Historically it is a place of outstanding learning and culture, and yet it has on occasion been the scene of uncontrolled mob violence, savagery and the commission of crimes of exceptional brutality or of such a bizarre nature that they pushed back the boundaries of what was known or thought possible. Even today, the largely sanitised and grossly commercialised Old Town somehow manages to retain corners with a vestigial sense of the skulduggery that has played so significant a role in its past. Surgeons and doctors trained in Edinburgh have had an enormous and beneficial impact across the world and in recent years they have been at the forefront in such areas as transplant surgery, yet it is only fifty years ago that the city pumped all its sewage, raw and untreated, into the Firth of Forth, whereupon much of it, predictably, washed up on the coast nearby. While the city's medical schools and teaching hospitals vie with any in the world, Edinburgh currently has an unenviable record on heart disease. The diet of the city's residents is often blamed for its poor record on that particular issue. Over the years, Edinburgh has given the world outstanding engineers, scientists, philosophers, artists, poets and writers and other people of influence nationally and internationally – in numbers totally out of proportion to its relatively small population – and it is justifiably proud of the fact. Yet it is also the city that acted as the inspiration for the anarchic, hopeless nihilism of the film *Trainspotting*, made in 1995. In the elegant New Town, the city boasts one of the best-preserved examples of early town planning anywhere in the world, and yet there are still bleak peripheral housing schemes which are festering pockets of deprivation and despair.

Edinburgh is a city of quite extraordinary diversity. It is a capital, the centre of Scotland's government and administration. It is internationally famous for law and jurisprudence and an educational, and as a research centre of worldwide renown. Its cultural festivals are respected across the world. It is a transport hub, possessing

one of the UK's leading airports. It has a seaport and is a major railway centre. It even possesses a seaside with miles of gorgeous and usually quite lonely sands. Edinburgh is a tourist attraction of world stature, and possibly the only large British city that could reasonably be described as beautiful. If beauty is not conceded, then few would argue that Edinburgh certainly has striking visual elements, including Arthur's Seat and the castle poised majestically on its rock above the city. A visual delight of Edinburgh is the fact that there are places in the city centre from which both the sea and sizeable hills can be seen.

Edinburgh has masses of open space and is hugely proud of its sporting associations, some of which use these places. The city is enormously conscious of its history and heritage and few cities can vie with it for its sense of commemoration – indeed it has much to remember and to cherish. It was formerly a manufacturing and industrial centre of moderate importance and some evidence remains of this role. Edinburgh remains predominantly a city of sandstone buildings. An initial impression is that these are grey. In the past, those in central Edinburgh were blackened, the result of the smoke-laden atmosphere which gave the city its affectionate, if somewhat mocking, nickname, 'Auld Reekie'. Closer examination of the local sandstone reveals variations in colour from pinkish grey through yellowish brown and greyish orange to dusky brown. The quarries in the neighbourhood, the best-known of which was Craigleith, near the Queensferry Road, were becoming worked out by the late nineteenth century, and then an attractive, warm red sandstone from Dumfriesshire was brought in by rail for building purposes. Roofs were consistently of slate, mostly brought from Ballachulish in north-west Scotland. Edinburgh still displays huge numbers of that characteristic Scottish urban dwelling, the tenement block. These form a fascinating subject for study in their own right, varying from the intended elegance of the tenements to be found in Marchmont and Morningside, for example, to much plainer, even austere, blocks of such dwellings in the Easter Road area and other, more proletarian, districts.

Edinburgh is a grand city for walking across and around, although the fact that much of it is hilly means that reasonable fitness is a necessity and the vagaries of its climate require the walker to be prepared for just about anything and everything in the way of weather. Its cornucopia of visual interest and stimulation is the inspiration for this current work. Edinburgh is a city aware of its history and this is reflected in a quite extraordinary number of monuments, memorials and plaques, of which only a sample can be described here. The intention of the author is to draw attention particularly to some odd and curious pieces of historical paraphernalia that can be seen in its streets, paths, parks and other public places, and he rarely mentions anything inside buildings or on any premises that are private or for which an entry charge is levied. He does not attempt a comprehensive coverage of all parts of the city, for this would require a much larger volume and the wearing down of even more shoe leather. Inevitably, most of these oddities or items with

interesting associations are found in those districts largely built up before 1900, and these are relatively compact. He found in the phrase 'street furniture' a handy flag of convenience, because while the items about which he writes can indeed be seen in the streets or from the streets, roads and paths, perhaps not all of them fall into the commonly accepted category of street furniture. He tends to ignore much of the modern clutter of items littering the streets of Edinburgh, many of which are devoted to telling the motorist or pedestrian what he or she can't do or must not do at that point. He ignores it because it is often tacky, is not interesting and is never likely to be, except perhaps when it becomes obsolete and starts to disappear and thereby gains a certain curiosity value.

The author greatly enjoyed poking about sometimes quite obscure parts of Edinburgh, unearthing and researching those items he writes about, but he is only too aware that this is only a partial selection and that just around the next corner there were probably some gems that he missed. The choice of what has been included is purely his own. There were also items that attracted his attention but about which he could find no information, and so these have not been included. He is aware that there is an undue concentration in the book on that part of Edinburgh south of the Old Town, and especially the Southside. He intends no disrespect to other parts of the city, but it is simply that this is the part of Edinburgh he knows best. All the places mentioned have been visited by the author in recent years, but such is the pace of change that he cannot guarantee that everything mentioned is still *in situ*. Where changes have occurred subsequent to his last visit, he can only apologise. He recommends the use of a good street map for navigating round the city and he provides the postal district of most of the items he includes. He particularly hopes that his interest in the odd and obscure is evident, and that his love of and admiration for Edinburgh also comes across to his readers (if any).

The photographs were all taken by the author and have deliberately excluded many of the city's best-known sights, which have been photographed a million times before (but not by him).

A brief introduction to the history of Edinburgh is provided for those who want to understand more about the context and conditions which have produced so much of interest in this fascinating city.

A BRIEF INTRODUCTION TO THE
HISTORY OF EDINBURGH

Like Rome, Edinburgh is built on seven hills, prominent among which are those comprising the plugs or other components of long-extinct and once much taller volcanoes. It is thanks to these that the city enjoys her spectacular topography and what, for many people, is her beauty and unique character. Edinburgh's climate could, not unfairly, be described as 'robust'. It is raw with the kind of cutting edge that finds and then strikes remorselessly through any interstices in the clothing and it is usually at its worst between mid-October and mid-April. On those occasions when a 'haar' blankets Edinburgh, mostly but not exclusively in the same period, Edinburgh can seem one of the most cheerless places on Earth. A haar is a thick, clinging mist often accompanied by a chilling, penetrating wind from the east. One of the city's most eminent sons, Robert Louis Stevenson (1850–94), described Edinburgh's climate as 'one of the vilest under heaven' and like many others, he escaped to more congenial climes elsewhere. By way of the contrasts that are so typical of Edinburgh, rainfall is moderate and in midsummer it can still be light at midnight.

The ancient name of Edinburgh was 'Din Eidyn', which meant 'Fort of Eidyn'. This evolved into Dunedin, and later Edinburgh. The fort was established on what is now called Castle Rock, a volcanic plug which originally marked the southern boundary of the Kingdom of Scotland. Edinburgh's dramatic topography is the result of two very different types of geological activity. The first was the volcanic activity mentioned earlier. The second was glaciation. The volcanic plug on which the castle stands was gouged and scraped by ice caps moving generally in a southerly direction. They account for the steep sides of the Castle Rock, but that rock itself gave some protection to what is now the steep-sided ridge descending from the Castle to Holyrood Palace.

The Romans had a military presence in the Edinburgh area because they felt threatened by various Caledonian tribes who frequently raided and marauded

as far south as what are now the northern counties of England. Hadrian's Wall was built in a not totally successful attempt to contain them. In what might be described as a pre-emptive action, the Romans created the sixth British province of Valenta, which occupied much of what are now the Lothian and Strathclyde districts. Forts were established at Fisherrow, to the east of Edinburgh, and at Cramond to the west, the latter being a supply station for the Antonine Wall. This was a secondary defensive earthwork running from the Forth to the Clyde. It was probably originally designed as a base from which the Roman military forces would sally forth to conquer and subdue the fierce people of the Highlands, an enterprise which they eventually and wisely decided was not sensible or practical.

The Romans occupied the Scottish lowlands in what was probably a rather uneasy relationship with the indigenous population. Eventually, however, troubles at the beleaguered hub of the Empire caused the last Roman soldiers to leave in AD 443, whereupon Scotland for several centuries became a battleground between the local people and Saxons from Northumbria. It was probably in 682 that an earlier fort was rebuilt in stone on what is now the Castle Rock by King Edwin of Northumbria to mark the northern extent of his kingdom. The presence of this fort would have provided some sense of security in turbulent times and a settlement grew up in the lee of the rock. By 854 this settlement had grown sufficiently for the English bishopric of Lindisfarne to decide that a small chapel should be built in which the Word could be preached to the local people. When built, the chapel was dedicated to St Giles. The Pictish and Scottish people evolved an accord and united to form a kingdom of the Scots, which, perhaps wisely, held court at Scone in Perthshire or at Dunfermline, both places being comparatively safe because they were north of the Firth of Forth, a feature which presented a formidable obstacle to any armed force moving northwards with hostile intent.

It was only in 1018 that Scotland under Malcolm I was able to assert itself sufficiently to extend the kingdom's boundaries southwards as far as the River Tweed after inflicting a heavy and decisive defeat on the Northumbrians. In 1068, Malcolm III and his wife Margaret, who was the grand-niece of Edward the Confessor, decided to build a strongly-fortified palace on the highly defensible Castle Rock. Within the precincts of this palace-cum-castle, a chapel was erected and this survives as the oldest building in Edinburgh. King David assumed the throne in 1107 and proceeded to create a little medieval walled town on the slope of the hill ascending to the castle. This nucleus of the future Old Town was roughly from the castle down to the present-day intersection of the High Street, North Bridge and South Bridge. No trace of this town wall survives, which is not surprising because it was built of turf and earth with wooden gates topped by spikes.

Edinburgh began to be one of the main centres for the Scottish court and the town became a royal borough and an increasingly important administrative and commercial centre. The small chapel of St Giles was substantially rebuilt and some

traces of the fabric of this time can still be seen. The process of growth was aided in 1128, when Holyrood Abbey was established at the foot of the hill leading up to the rock on which the castle stood. It became the centre of a large monastic community and, as so often happened, it attracted businesses and a workforce to do the jobs the brethren could not do. As the abbey developed and prospered, the community around became known as Canongate, and such was the clout of the abbey that Canongate in due course became a borough in its own right. The story goes that the abbey was founded after King David chose to go hunting on a holy day when such frivolous activities were proscribed. He was attacked by an angry, wounded stag which knocked him off his horse and would doubtless have gone onto trample him to death when, most unexpectedly, a cross suddenly appeared between its antlers. This apparently caused it suddenly to stop its attack on the helpless king. He was of course grateful for this, but also contrite about frittering away a holy day at the hunt and so he decided then and there to found an abbey. The crest of the Burgh of Canongate displayed a cross and a stag's head.

Robert the Bruce granted Edinburgh a new royal charter in 1329 which gave it jurisdiction over the port of Leith, about two miles down the hill from the castle. It had been Robert I, 'The Bruce', (r. 1306–29) who, in defeating the English so decisively at Bannockburn near Stirling in 1314, established Scotland's nationhood. But despite that, Edinburgh continued with almost monotonous regularity to be captured, burnt and sacked by the English and then retaken by the Scots. The port of Leith developed a busy and lucrative seagoing trade with countries in Scandinavia and around the Baltic Sea, trade which brought considerable prosperity to Edinburgh. This provided the resources needed later to build fine defensive walls and for Edinburgh to establish itself as the modern capital of Scotland.

During the reign of James IV (r. 1488–1513), a royal palace was built at Holyrood, adjacent to the abbey, and a royal charter was granted to the College of Surgeons, an indication that even at this early date, the city was developing as a centre of culture, science and learning. Many other prestigious professional and academic bodies would be established in Edinburgh in the years to come. A particular high spot occurred in 1503, when James married Margaret Tudor, daughter of Henry VII of England, in a glittering pageant at Holyrood. James, dressed in a jacket of crimson velvet trimmed with cloth of gold, met his new bride at Dalkeith and escorted her in a grand procession to Edinburgh. Crowds lined the route, the bigger houses were bedecked with gorgeous tapestries, and a fountain ran with red wine.

Edinburgh's successful growth and progress rested on two developments: its increasing domination of the export trade from Scotland after Berwick-upon-Tweed had been lost to the English in 1334; and its status as the country's capital from the reign of James III (r. 1460–88) onwards. For example, by the 1590s, 90 per cent of Scottish wool exports were passing through the port of Leith. The city had

many very wealthy inhabitants, although the vast majority of its population lived in appalling poverty and squalor. Those who were affluent mostly obtained their riches from involvement in foreign trade or as leading lights in the craft and trade guilds. From the sixteenth century, the city developed into a significant industrial centre with dye works, paper mills, printing works and breweries, for example.

This progress was temporarily set back in 1513, after the appalling defeat suffered by the Scots at the Battle of Flodden. This led to a period of economic, social and political instability. King James V (*r.* 1513–42) had been answering a call to assist Scotland's old ally, France, against her old enemy, England. He marched the largest Scottish army ever assembled towards England, only for it almost to be annihilated by a much smaller English force at Flodden, between Wooler and Coldstream. This rekindled fears of yet another invasion by the English and so the 'Flodden Wall' began to be built, a strong defensive vallation around the south of the city, parts of which can still be seen.

Enclosed in its walls, Edinburgh felt rather more secure than before and as its prosperity developed, this was reflected in grand buildings such as Gladstone's Land in the Royal Mile. At the same time, the population grew and what is now known as the Old Town became grossly overcrowded. The physical site meant that there was little option but to build upwards. Many multi-storey buildings were erected, crammed to the gunwales with residents, the best-off of whom lived on the uppermost levels. Edinburgh can truly be said to be the place where the high-rise building first saw the light of day. Even at a time when no concept of public health existed, Edinburgh was notorious as a stinking, pestilential place. It was still growing in overall wealth and importance, however, and it was during the sixteenth century that St Giles Kirk developed into the fine building we can still see.

In the 1540s, Henry VIII's determination despite Scottish opposition to wed his son Edward to Mary Stuart, otherwise known as Mary, Queen of Scots, led to the English carrying out a scorched-earth type of invasive warfare ironically called 'the Rough Wooing'. Not much actual wooing took place as his forces ranged through lowland Scotland, burning, looting, robbing, raping and murdering, a process culminating in the sacking of Edinburgh itself. This humiliation prompted the Scots to turn to the French for assistance and a sizeable force of French troops guarded the city while the young Mary, much to Henry's chagrin, was dispatched to Paris to become the bride of the young and effete dauphin. The French presence may have deterred the English from more military adventures in Scotland, but the native Scots did not like the strutting triumphal ways of the French and this probably helped to push them in the direction of the Protestant Reformation. When John Knox returned from exile in 1555, his anti-Catholic message found huge numbers of adherents in lowland Scotland.

In 1582, James VI founded the University of Edinburgh but doldrums for the city were to follow his accession to the throne of England. It was as if James could

not wait to leave Scotland, Edinburgh in particular, and the city soon found itself totally upstaged by London as the two kingdoms were joined. James had left solemnly promising that he would return every three years, but it was not until 1617 that he made his solitary return trip. In 1633 Charles I visited Edinburgh as a piece of public relations, but quickly undid any good effect resulting from that gesture when he managed to antagonise vast swathes of Scottish folk by introducing bishops to the Church of Scotland. Fifty years of bitter religious dissension followed, culminating in the establishment of Scottish Presbyterianism. Edinburgh was constantly at the centre of the turmoil.

For all that, Edinburgh's significance in the life of Scotland continued to rise as it officially became a city and grew even more overcrowded. It grew not only upwards but downwards, having many dwellings literally carved out of the rock on which the Old Town was built. The chronic overcrowding and jerry-building that characterised the Old Town constituted a considerable safety hazard and in 1700 a devastating fire, one of many over the years, caused the city burghers to require that all future buildings should be made of stone. The environmental horrors of the Old Town were not helped by the presence of the Nor' Loch. This was immediately to the north of, and far below, the rock on which the Old Town stood. It consisted of a small loch and a boggy area and stank to high heaven, especially in the summer, because into it flowed the drains of the Old Town; it also acted as a convenient repository for all manner of refuse and filth. It was only to be expected that Edinburgh suffered frequent visitations from devastating epidemics. These included plague (for the last time in 1648), cholera and typhus. Edinburgh was not a healthy place in which to live.

In 1637, when the new English litany drawn up by Archbishop Laud was read for the first time in St Giles Kirk, Jenny Geddes, a local market stallholder, had her moment of celebrity when she threw a stool at the preacher, giving vent to the outrage that she and so many others felt. Within a year, all Lowland Scotland was up in arms. The National Covenant declaring support for the Presbyterian Church had been signed in Greyfriars Kirk and bands of Covenanters were roaming across the country, attacking any castles and other places associated with the English. In 1650 Cromwell's English forces attacked Edinburgh, but initially they were repelled. Soon afterwards, Cromwell won the Battle of Dunbar and he was able to enter the city unchallenged. He proceeded to establish martial law. During the period of the Commonwealth, General Monck, his right-hand man, ruled the city with a rod of iron and the stability that ensued enabled Edinburgh to enjoy a period of considerable prosperity, even if local people hated the English presence. They were elated when Charles II returned to the throne in 1660 – a Stuart was king again. Charles was followed by the fervently Catholic James II, who was unpopular north of the border. For this reason, most Scots welcomed the accession to the throne of William and Mary.

The union of the Scottish and English parliaments in 1707 dealt a further blow to Edinburgh's national and international political prestige, although Scotland managed to retain control of its national Church and its legal and educational institutions. The city went on to carve out a prominent place for itself as a major ecclesiastical, legal and educational centre. The politicians and what we would now call senior civil servants with their assortment of hangers-on, spin-doctors, toadies and lickspittles, left for London, eagerly sniffing out the opportunity to make lucrative and prestigious careers for themselves there.

Living standards were undoubtedly lower in Scotland than in England, and there were many people in Scotland who felt that this fuller union with England was not to their advantage. For that reason, it was decided to establish an overseas colony of Scotland's very own, and the place that was chosen was Darien on the Isthmus of Panama. It was hoped that untold riches from the exploitation of raw materials, trade and commerce would be forthcoming and would produce a brave 'new' Scotland. In the event, the Darien venture was an unmitigated disaster. The majority of ships that set out were wrecked en route and the small number of would-be settlers who actually got to Darien found only disease, starvation and hostile natives. A huge amount of capital had been invested in the enterprise and almost all of it was lost in a venture so disastrous that it set the Scottish economy back many years, the impact being felt particularly seriously in Edinburgh, where much of the investment had been raised.

This left something of a black hole, but then Edinburgh developed a role which it had already carved out for itself in a minor way: it became a major attraction for those of a cerebral bent. In the second half of the eighteenth century, Edinburgh achieved a position of the utmost eminence in the European Enlightenment. It was at the cutting edge of the development of ideas and the intellect. Among its luminaries were David Hume (1711–76), the philosopher, and Adam Smith (1723–90), the political economist. Over the following century or more, Edinburgh produced hundreds of people (and given the times they were of course virtually all men) who became eminent in the fields of engineering, science, medicine, literature, art, architecture, law and philosophy. Also educated in the city were innumerable colonial administrators, soldiers and explorers. This time was truly a great one in Edinburgh's history.

One final act of stormy Scottish history still had to be acted out on the city's streets. On 15 September 1745, Prince Charles Edward Stuart entered Edinburgh with a force of 2,000 Highlanders and remained in the city for about six weeks. The Castle was occupied by a small garrison of English troops. A rather half-hearted siege took place and a number of citizens were killed or injured in the crossfire, but on 31 October 1745 Bonnie Prince Charlie abandoned the siege and led his followers to England on what was to prove a disastrously abortive attempt to seize the throne. Only hours before, the Castle, which had witnessed so many momentous events over the centuries, fired its last shots in anger.

Within twenty years, work began on the building of the New Town on the slightly higher ground across the Nor' Loch. This was a masterpiece of town planning in the neoclassical style and evidence of the wealth and prestige which was accumulating in Edinburgh. No other city in the British Isles had such a large proportion of its population employed in the professions. The New Town was planned as an elegant, spacious and exclusive residential suburb for those numerous citizens who had both money and social position. For this suburb to be created, bridges had to be built across the chasm housing the Nor' Loch and the first of these was North Bridge, work on which started in 1763. The successor to it still straddles the east end of Waverley Station. The residential and, with the private gardens, recreational aspects of the New Town were flawed almost from the start. The first building to be opened was the Theatre Royal and, within ten years, most of the houses along the north side of the developing Princes Street had become shops. Although such trends may have had a damaging effect on the integrity of this high-class suburb, in later years the fact that the New Town existed at all had an inhibiting effect on the development of the kind of large-scale commercial building projects that might have been expected in the centre of a prosperous city that was growing rapidly in the nineteenth and twentieth centuries.

At some point, probably in the late nineteenth century, Edinburgh's supposed physical similarity to Athens was noticed. So Edinburgh, in today's parlance, re-branded itself as a city of classical architecture with a crop of buildings on Calton Hill, including an incomplete version of the Parthenon and various other Greek-inspired monuments, and such neoclassical buildings as the Royal Scottish Academy and the National Gallery of Scotland on the Mound. This steep road was developed as another route joining the Old Town and the New Town and utilised material removed during the building of the latter.

Those who could afford to do so got out of the Old Town and moved to the much more salubrious surroundings of the New Town. Those who continued to live in the Old Town did so mostly because they had little or no option. The Old Town became an appalling, squalid and sinister slum wracked by epidemics. Crime, deprivation and despair stalked the lanes and wynds.

Edinburgh's self-conscious role as the modern Athens was crowned by the visit of George IV in 1822. He was dressed very nattily, if a trifle inappropriately, in pink tights under a kilt. The year, if not the occasion, perhaps marks the heyday of Edinburgh as an epicentre of intellectual achievement in the arts and sciences. Edinburgh had huge numbers of eminent surgeons, physicians, philosophers, lawyers, advocates, artists and men of letters. Their presence was reflected in the proliferation of gentlemen's clubs, bookshops and literary and critical journals and magazines that were being published locally. Edinburgh further enhanced its reputation as an educational centre with the opening of such prestigious academies as John Watson's, Donaldson's Hospital, Daniel Stewart's and Fettes College.

These tended to be housed in impressive mansion-like buildings, perhaps having a Scottish baronial appearance or of a style defying description but most easily categorised as 'eclectic'.

In the second half of the nineteenth century, prosperous middle-class suburbs developed around Edinburgh, most particularly in the Southside. These districts were and are still largely composed of seemly villas in sizeable grounds and high-class tenements in such areas as Grange, Sciennes, Marchmont, Merchiston, Newington and, best-known of all, Morningside. From the very start, the latter in particular incurred ridicule for its supposed smugness and pretentiousness, and indeed Robert Louis Stevenson urged Edinburgh's citizens to rise *en masse* and destroy such places. Despite Stevenson's fulminations, they have matured into some of the most attractive inner-city suburbs anywhere in Britain. As these districts developed, the older parts of the city, especially the Old Town, stood out in stark contrast as festering rookeries of slum housing, suffering despair, criminality and environmental blight. These conditions were only slowly tackled by the local authority. Even today, there are odd corners of the Old Town, for example around the Cowgate, which still exude at least some hint of the dark horrors of the past. The Old Town in the late nineteenth century was thought to be the most overcrowded urban quarter in the whole of the British Isles.

Parts of Edinburgh are very hilly. In 1888 electric tramways, a form of public transport as much associated with Edinburgh as with its very different 'rival', Glasgow, started operating. Trams were well-suited to hilly routes. The last trams ran in 1956 and, for many, Princes Street has never been the same place since the long lines of trams, nose-to-tail and in their dignified madder and white livery, went off to the great tram depot in the sky. It is an irony of course that trams, albeit of a very different type, will soon be seen on the city's streets once more. The first mainline railways serving Edinburgh opened in the 1840s, joining Edinburgh to Glasgow and Berwick-upon-Tweed. Edinburgh developed a complex and comprehensive railway system, most of which has been closed. Waverley, however, remains one of the most important hubs of the railway system of Britain. The other main station, Princes Street, was at the far end of that main artery and lurked behind the Caledonian Hotel. Although itself quite grand, it closed many years ago when its services were either withdrawn or diverted into Waverley.

The changes associated with the Industrial Revolution affected Edinburgh much less visibly than Glasgow and other great British cities. Edinburgh continued to be a centre of government, administration, law, finance, culture, education, medicine and research. Edinburgh was and remains a city preoccupied with what we would now call the tertiary or service sector. It still has a predominantly white-collar character. The spending power of its population was once reflected in the luxury trades that could be found, such as gold- and silver-smithing, and also in a quirky occupation such as wig-making, which had everything to do with the vast army

of law professionals to be found locally. The spending power of the better-off of the city's present-day population is now indicated, for example, by the plethora of expensive eating places. Edinburgh did have some manufacturing and processing industries, but on nowhere near the scale to be found in Glasgow. It was a centre of brewing until the 1980s, and it also possessed distilleries. The scholarly needs of the place led to it becoming a centre of printing and publishing. Paper-making, rubber-manufacture and glass-making made up some of the other industries.

Mention has been made of Leith acting as Edinburgh's seaport. Having this facility facing northern Europe was a huge advantage to the city, and to lowland Scotland, from medieval times at least until the 1960s and 1970s. Ship-building took place at Leith. The town is still a seaport dealing with ocean-going ships, but on a considerably reduced scale. Leith has seen much redevelopment and gentrification in the last twenty years, but there are odd corners that still manage to exude some of the seedy and even rather threatening atmosphere characteristic of seaports of the past, even if these places in Leith are largely in decay and being systematically excised.

Since the Second World War, tourism has become a major earner for Edinburgh and brings money in throughout the year. With devolution, the Scottish Parliament based in the city has gained control over a large amount of Scotland's domestic economic, social and political agenda, but such is the nature of political organisations that a huge, cumbersome bureaucracy has grown up to service it. It was thought that making Scotland an international centre of financial services was the route to a brave and lucrative new world, but many of those involved had their fingers burnt in the recession of recent years. The Edinburgh Festival, which was first staged in 1947, has grown to become the largest such event in the world and contributes hugely to the local economy.

However, in the 1950s and 1960s, there was a sense that Edinburgh was stagnating. There were proposals that inner-city urban motorways were the solution to the increasing traffic problems and, had these gone ahead, they would have cut swathes through some of the most architecturally and historically significant parts of the city. A visit to Glasgow shows how such enthusiasm for urban road-building can have destructive and divisive effects. Needless to say, there were those who argued in all seriousness that without these roads, Edinburgh would wither and decay. A tight rein has been kept on planning in central Edinburgh, but Princes Street, with its incomparable closeness to the gardens and views of the Old Town and the castle, is now little more than an elongated high street with the kind of standard multi-outlet shops that can be found in any big city. Those who allowed the St James Centre in Leith Street to be built should have been roasted slowly over hot coals. Certain other developments of the last forty years also manage to stick out like sore thumbs. In fairness, some recent redevelopment has been less obtrusive and more sympathetic to its surroundings while managing to be in contemporary architectural styles.

In the post-war decades, new local authority housing, mostly around the periphery of the city, replaced much of Edinburgh's worst housing. Some of these housing schemes, such as that at Craigmillar, were mostly in districts largely unvisited by tourists and they degenerated rapidly into slums themselves and gained an awesome reputation for social exclusion, poverty, crime, drug abuse and AIDS. The well-known film *Trainspotting* encapsulated this aspect of the life of the city. A bleak and black film, although not without a few comic highlights, it got its name because many of the smackheads used a derelict railway station in Leith as the place to obtain and take their drugs. The city council was very unhappy about the way that Edinburgh was portrayed and they discouraged filming on location in the city. As it happened, much of the film was shot in Glasgow, hardly a compliment to that city. Even today, however, there are guides to Edinburgh which urge their readers not to venture into parts of Leith on their own, especially after dark.

Paradoxically, Edinburgh has a reputation for being somewhat smug, aloof and stuffy. This is obviously a matter of opinion, and it is certainly not the author's view. He has always found the ordinary people of Edinburgh extremely friendly and courteous. Edinburgh is a world city of vibrancy and style, the showcase of Scotland. It is historic, cosmopolitan and cultured. An apparently disproportionate percentage of those walking the streets seem to be young, which adds to the air of vitality and vibrancy. In uncertain economic conditions there is plenty for youth to be fed up with, and perhaps it is not just those who have just left slum schools with no prospect of meaningful employment in the foreseeable future who can be seen drinking, eating out and spending with apparent abandon. For all the contrasts, Edinburgh possesses an ambience and attractions that hundreds of thousands of visitors annually seek out, absorb and appreciate. The town planners have imposed some awful gaffs on the city, not least the appalling wart that is the St James Shopping Centre, mentioned above and mentioned again just in case the point was missed. They have destroyed worthy old buildings, replacing them with others that will never be worthy of anything. Somehow, the city rises above such things and continues to give enormous pleasure, visual and otherwise. Most of the locals are rightly proud of it. Edinburgh is simply unique. It will always remain so.

OUT AND ABOUT

1. ASTLEY AINSLIE HOSPITAL, EH9

The first parts of this hospital opened in 1923. It now specialises in post-acute care and rehabilitation for patients with conditions such as strokes, cardiac disease and brain disease. It occupies a site which consisted of four mansions and their extensive grounds.

One of these mansions was Millbank Villa, and in the hospital grounds on the site of this villa a plaque commemorates the fact that for some years from 1842 the mansion was the home of James Syme. He was Professor of Surgery at the university and one of the most eminent surgeons in Europe. The plaque also records the fact that in the Villa, Syme's daughter Agnes married Joseph Lister in April 1856. Lister (1827–1912) is famed in the annals of surgery for being a pioneer of sterilisation. Developing the work of Louis Pasteur, he began soaking his instruments and surgical gauzes in carbolic acid. He was the first medical man to be elevated to the peerage. He was at one time Professor of Surgery at the University of Edinburgh.

2. BALMORAL HOTEL, PRINCES STREET, EH2

The bulk of this extraordinary building demands attention as it lours over the east end of Princes Street. The hotel was started in 1895 and was completed and ready for business in 1902; it was then owned by the North British Railway Company. It was designed to be the last word in luxury and to appeal to rich travellers using Waverley station. It even had a private lift which connected the hotel and the station directly.

In 1981 the hotel was sold by British Rail, and in 1988 it underwent such an extensive refurbishment that it was closed for business for three years. When it

reopened it was renamed 'the New Balmoral', although people continued to think of it as 'the North British'.

Clocks are items of street furniture. The tower housing the Balmoral's clock is 195 feet high. It is one of Britain's most famous public clocks and it never tells the right time; it is set two minutes early to enable people to use those two extra minutes in order to locate and catch their train in the great wen that is Waverley station.

3. BARCLAY TERRACE, EH10

Shop signs used to be very common in the days of mass illiteracy. They tended to be eye-catching, and to provide a powerful visual image that made clear the nature of the business being carried on in the premises concerned. They have become steadily scarcer over the last fifty years. One sign that has managed to survive in some numbers is that of the barber's shop. This has traditionally been a white pole with a red band wound around it, symbolic of a blood-stained bandage and of the fact that until the nineteenth century, barbers acted as poor people's surgeons. They carried out blood-letting and tooth extraction, and they lanced boils, treated piles and carried out simple surgery for a range of everyday afflictions. Their activity virtually disappeared in the nineteenth century as physicians and doctors hastened to establish professional standards and qualifications and to monopolise the practice of medicine. In achieving this, they discouraged self-medication and ruthlessly shouldered aside alternative practitioners.

Not far away, in Marchmont Road, a chemist's pestle and mortar sign can be seen. These were also once very common.

4. BIBLE LAND, CANONGATE, EH8

On the north side of Canongate at nos 183–7, this building is known as Bible Land because above a door is a carved panel containing a biblical text. The building was once occupied by the Guild of Cordwainers of the Canongate. These were skilled workers in leather. Originally, they used goatskin imported from Cordoba in Spain, hence their name. The panel shows the trademark of the cordwainers, which is a rounding knife, and rather oddly it appears between two cherubs. What is their purpose? The inscription reads:

> Behold how good a thing it is
> And how becoming well
> Together such as brethren are
> In unity to dwell
> IT IS AN HONOUR FOR MEN TO CEASE FROM STRIFE

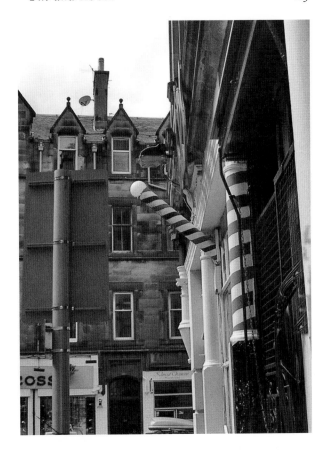

Barber's shop sign, Barclay
Terrace, EH10.

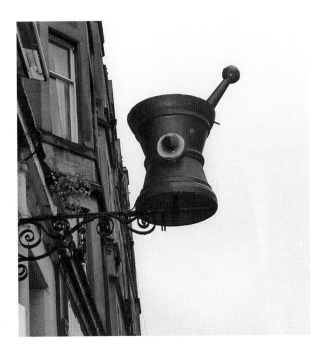

Chemist's pestle and mortar sign,
Marchmont Road, EH9.

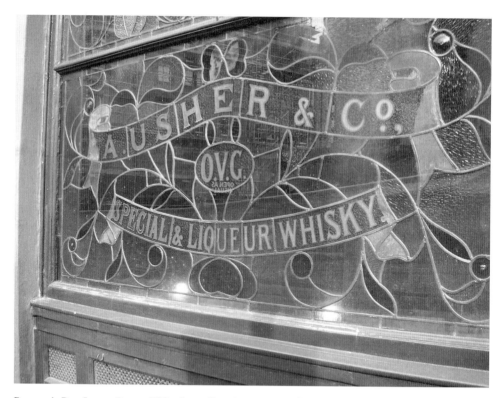

Bennett's Bar, Leven Street, EH3. In earlier times, it was thought highly undesirable that people on the street should be able to see into licensed premises. In Victorian and Edwardian times especially, pub windows, while admitting some light, were often utilised as advertising space particularly for breweries and their beers or distilleries and their products. Some delightful artwork resulted. In the holocaust of wilful vandalism which has passed for pub refurbishment, such features have mostly been destroyed, but this Tollcross pub still displays a couple of elegant stained-glass windows. There are some fine fittings inside as well. The brewery mentioned is Thomas Usher & Son, which had a brewery in the St Leonard's district. After changes of ownership, brewing ceased in 1981.

Pious words indeed, but unfortunately the strife has not ceased, and shows no sign of doing so while wealth and power are at stake.

5. BLACKFORD QUARRY, EH16

Little trace exists of the former quarry at Blackford, but a footpath provides easy access to the Agassiz Rock in Blackford Glen. A plaque on this rock explains how the eminent Swiss geologist Louis Agassiz visited the site in 1840 and declared that it provided very striking evidence of the effects of glaciation, a view supported by later scientific investigation. Quarrying operations ended in the early 1950s. This area provides many delights for the contemporary walker and is readily accessible from central Edinburgh.

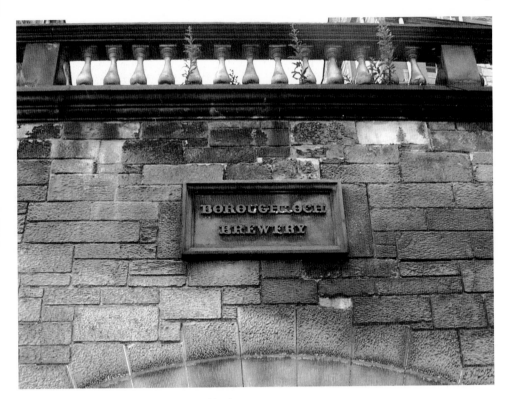

Arched gateway to the former Boroughloch Brewery.

6. BLACKFRIARS STREET, OFF HIGH STREET, EH1

This street, which drops steeply down from the High Street to the Cowgate, was the scene in 1520 of a well-known affray known as 'Cleansing the Causeway'. A monarch who was a minor ascending the Scottish throne was almost always a sure recipe for chaos as ambitious and unscrupulous so-called nobles jockeyed for power and influence. At this time it was the minority of James V and two rival regents, the Earl of Arran and the Earl of Angus, with their followers met for what began with a brawl and ended up as a small but desperate battle in what was then Blackfriars Wynd. About a hundred men lay dead or dying, and on this occasion victory went to the Earl of Arran. For those crowding the windows of the high buildings around, there had been an hour or two of glorious street entertainment. Such was Edinburgh in the 'good old days'.

7. BOROUGHLOCH, EH3

On this tucked-away lane close to The Meadows is the site of the former Boroughloch Brewery of Alexander Melvin & Co., which was founded in 1805 and where brewing

ceased in 1907. An archway with the words 'Boroughloch Brewery' can still be seen. Some of the former brewery buildings remain *in situ*, used for other purposes.

8. BRAID ROAD, EH10

Whoever would think that the serene surroundings of Braid Road once displayed a gibbet from which the bodies of two felons were suspended as a visible, gruesome but mute homily on the wages of sin? Close to No. 66, two square stones lie in the middle of Braid Road. These are the famous 'hanging stanes'. They mark the site of the gibbet. There is also a plaque close by, recording these events.

A common practice in the days of public hangings was for condemned felons guilty of particularly heinous offences to be executed at the scene of their crime. On 22 December 1814, two men appeared in the High Court in Edinburgh charged with three counts of highway robbery, one of which was alleged to have taken place in Braid Road. The men were said to have pulled one David Loch off his horse, beaten him severely and robbed him of five pounds, a loaf of bread and his tobacco pouch. The jury did not even bother to retire before pronouncing the men guilty. The judge, deciding to make an example of them because of his concerns about the apparent increase in the frequency of highway robbery, sentenced them to death. With relish, he aggravated the punishment by giving instructions that the execution should take place where the crime had been committed and that, after death, their remains should be placed nearby in a cage hanging from a gibbet. This would act as a deterrent to anyone passing by who might themselves be contemplating a spot of highway robbery. It should be mentioned that highway robbery at that time carried a mandatory death sentence.

The execution took place on 25 January 1815. Despite the fact that it was bitterly cold and heavy snow was falling, a huge crowd of people turned out to gloat as they watched the death agonies of the two miscreants. Nothing could guarantee a huge turnout more than a good hanging. This was the last hanging in Scotland for felons convicted of highway robbery.

9. BRIDGE ROAD, COLINTON, EH13

Close to where Bridge Road becomes Colinton Road, a small stone with the following inscription can be seen: 'This stone marks the line of the ancient route from the Pentland Hills to the Ford and Old Bridge over the Water of Leith.'

10. BRISTO SQUARE, EH8

Bristo Square is a piazza-like area fringing many large public buildings, including the McEwan Hall. A prominent feature of the square is the McEwan Lamp, which

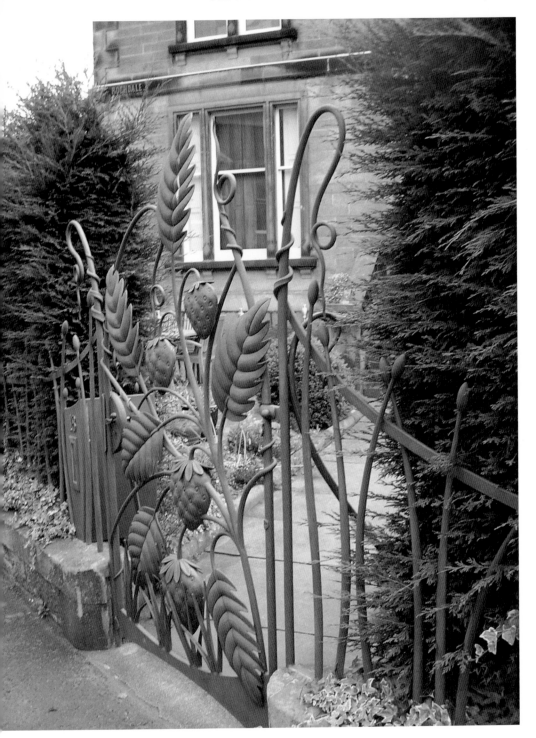

A delightful piece of decorative ironwork forming a garden gate in Bright's Crescent, EH9.

is a prominent and extremely ornate street lamp paid for by William McEwan of the famous local brewing family when he was an MP. It was erected in 1887 and was designed to use electricity, being a fine advertisement for this new lighting medium which had only come into use for the first time in Edinburgh a couple of years earlier.

11. BRUNTSFIELD GARDENS, EH10

Greenhill House was a large mansion formerly belonging to the Livingstone Family and the existence of the house is recalled by a plaque near the junction of Bruntsfield Place and Bruntsfield Gardens. The house itself was demolished in the 1880s.

12. BRUNTSFIELD LINKS, EH10

Bruntsfield Links, like the Meadows close by from which it is separated by Melville Drive, is a well-loved and much-frequented green open space. For centuries all manner of sports have been played on the Links, with an especially long tradition of short-hole golf. Some parts of the Links have a very hummocky appearance and this is because for many centuries the underlying sandstone was quarried to provide material for building projects in the city.

Looking out over Bruntsfield Links is 'Ye Olde Golf Tavern'. It pays to be sceptical about pubs called 'Ye Olde Anything', but in the case of the Golf Tavern the 'Ye Olde' is perfectly justified because it claims with some reason to date from 1456 and proudly displays the claim on its exterior.

13. BUCKINGHAM TERRACE, EH4

Buckingham Terrace follows the sinuous curve of Queensferry Road, and at No. 31 there lived a degenerate waster by the name of Donald Merret. Devoted to short-term hedonism, Merret's income did not match his outgoings. He hit on the idea, therefore, of forging his wealthy mother's name on cheques. This gave his finances a welcome boost, but it was only a matter of time before she found out. She was more saddened than angry, but he was definitely angry to be found out and he shot and killed her in 1927. He received twelve months' imprisonment for the forgery but was found 'not proven' for the murder because the defence were able to convince the court that suicide might have been a possibility. He spent the rest of his life engaged in a wide variety of criminal activities, including two more murders, but he eventually evaded justice by committing suicide. Edinborians will be pleased to know that this repulsive reprobate was English-born. There is no plaque on the building to commemorate Merret's life and works.

14. BURKE AND HARE PUB, JUNCTION OF FOUNTAINBRIDGE AND BREAD STREET, EH3

Pub names and signs are very definitely items of street furniture and are a fascinating study in themselves. Last time the author passed this pub it did not appear to have a sign, but it did proclaim pole-dancing among its attractions. He hurried on, not feeling tempted by such diversions. He prefers real ale and a good chat in a community pub and feels that pole-dancing might be something of a distraction from these old-fashioned but good things of life.

It is odd. London has its 'Jack the Ripper' pub close to where the mass murderer stalked the squalid streets in search of his victims. It was an early theme pub, displaying much memorabilia associated with these gory crimes. Here in Edinburgh, the choice has also been made to remember two of the city's most egregious criminals in a pub name. Burke and Hare were of course the two ne'er-do-wells who, running out of bodies deceased through natural causes, started murdering down-and-outs in the 1820s and selling their bodies as object-lessons to Dr Knox, a demonstrator and lecturer in anatomy at a popular school attended by medical trainees. He was by all accounts a superb lecturer and so successful that he needed a sizeable and continuous supply of cadavers to assist his work. Knox asked no questions about the provenance of the specimens he bought and he paid good prices during the short-lived symbiotic relationship he developed with his low-life business partners. He said his work was intended to benefit mankind, but this cut no ice with the Edinburgh mob which attacked his house. At least Burke and Hare never pretended that what they were doing was for anything but pecuniary gain (if they'd known what the word meant). The general feeling at the time was that Knox was every bit as culpable as they were in this singularly repulsive criminal activity; he must have known that the specimens he bought had been obtained by illicit means. Local pressure meant that Knox was soon forced to leave the city.

15. CAFÉ ROYAL, WEST REGISTER STREET, EH2

The brief of this book is the consideration of a random selection of historic, notable, quirky and curious things (some are all four) that can be seen from the streets, pavements and paths of Edinburgh. Well, rules are like pie crusts, they are made to be broken, and the author feels that it would be totally remiss of him not to mention what has to be the best pub interior in Edinburgh, although it is not necessarily the grandest. For all that, it is still pretty grand.

It may be evident that the author is fond of pubs and pub signs, or at least unusual or interesting ones. Edinburgh has several pubs with fine interiors featuring traditional Victorian fittings, but the Café Royal is different. It was built in 1861 and designed not as a pub, but as a showroom for plumbing and sanitary

ware. After it operated as a hotel for a period, it was given a refit and became a pub. No expense has been spared to provide a sense of opulence. It has a wealth of marble, high-quality polished woodwork, stained glass, moulded ceilings and chandeliers, but perhaps the most unusual and eye-catching feature is a series of tiled faience murals by Doulton. They feature historical innovators, including James Watt, George Stephenson, William Caxton and Sir Robert Peel. The latter was best-known for his establishment, against massive opposition, of the Metropolitan Police in 1829. He adorns the wall of the Café Royal, however, not as a politician but in his role as the industrialist and cotton baron who introduced calico printing.

16. CAIYSTANE VIEW, EH10

The Caiystane, otherwise known as the Cat Stane, Camus Stone or Ket Stane, has now become encircled in south Edinburgh suburbia. It stands an impressive nine feet above ground and is a monolith of red sandstone whose origins are unknown.

17. CALTON HILL, EH7

'The Athens of the North' is possibly a rather fanciful description of the city but perhaps an understandable one. Calton Hill is certainly one of the features that contribute strongly to Edinburgh's remarkable and unusual cityscape. Any view eastwards along Princes Street, so long as there is not a haar, inevitably draws the eye towards this small and fairly low but dramatically placed volcanic plug. It has a cluster of buildings, each of which is rather odd in its own way but, when they are taken collectively, they are positively eccentric.

The National Monument, designed by C. R. Cockerell in collaboration with the prolific local architect William Playfair, was intended to be a replica of the Parthenon, appropriate for 'The Athens of the North', and to act as a memorial for those Scotsmen who gave their lives in the prolonged wars against Revolutionary and Napoleonic France. Work started slowly in 1822, but ceased in 1830 when the money ran out completely. It was proving prohibitively expensive to transport the huge blocks of stone required for the building up such a steep-sided hill. Appeals went out for more funding but somehow or other this never happened, and so the city was left with a decidedly eccentric, partly-completed Parthenon, which looked from the start like a ruin. After a while the idea of a sham ruin caught on, and now local people would not have the National Monument any other way. They have given short shrift to proposals that have surfaced from time to time that it should be completed.

The Old Observatory was built in 1776, designed by James Craig, well known for classical buildings in the New Town. A case could be made that, like the National

Monument, this is a folly because of its mock fortifications. Even in eighteenth-century Edinburgh, it seems unlikely that an observatory would need to have been fortified. It was built at a time when there was a burgeoning interest in astronomy and it was intended to house a telescope through which interested members of the public could pay to peer and stargaze. It was never a success in this role. Less peculiar is the New Observatory, designed by Playfair in 1818. It is domed and exudes a Doric character. As an observatory, it was not a howling success either. The murky atmosphere generated by the mass of coal fires which gave the city its former nickname of 'Auld Reekie', plus the smoke from steam locomotives puffing around in Waverley station, rendered it useless for much of the time.

Right up there among the leading follies of Scotland is the Nelson Monument, started in 1807 and finished in 1816. This was designed by Robert Burn in a Gothic style and is surmounted by a tall tower deliberately designed to look like an upside-down telescope. It sports a device which allows a time-ball to fall at 1 p.m. every day of the year. This contraption is therefore of great assistance to those who do not possess timepieces of their own or cannot see the clock on the tower of the huge hotel in Princes Street, now sadly renamed the Balmoral from the North British. Equally, it can be of assistance to those with a hearing impediment, which means that they are unable to catch the sound of the gun fired at the same time every day from the castle ramparts. An inscription runs: 'To the Memory of Vice Admiral Horatio Lord Viscount Nelson, and of the great victory at Trafalgar, too dearly purchased with his blood, the grateful citizens of Edinburgh have erected this Monument: not to express their unavailing sorrow for his death; nor yet to celebrate the matchless glories of his life; but, by his noble example, to teach their sons to emulate what they admire, and, like him, when duty requires it, to die for their country. A.D. MDCCCV'.

The syntax may be a trifle odd and the sentence overly long, but the sentiment is understandable. When the memorial was completed, some of the city's more fastidious elements thought it should be demolished because it was so ugly. Some rooms at the bottom of the building were originally intended to be a rest home for disabled mariners, but there were no takers for this generous gesture. Perhaps they were too disabled to face the climb up the hill. The view from the top of the Monument is superb, but getting up the steps is not for the faint-hearted and certainly not for disabled mariners.

The Playfair Monument is almost incestuous because it was designed by the prolific William Playfair to commemorate his uncle, the eminent mathematician and astronomer Professor John Playfair. The Dugald Stewart Memorial, commemorating a noted professor of moral philosophy at the University of Edinburgh and gifted lecturer who died in 1828, is modelled, like the Burns Memorial not far away, on the Choragic Monument of Lysicrates. Is there any other city in the world that has two replicas of the Choragic Monument so close

to each other? This, the author hastens to add, is a rhetorical question. It is hardly necessary to say that the Dugald Stewart Memorial is yet another work from the hand of William Playfair.

One way of climbing Calton Hill is to take the steps that rise from Waterloo Place, opposite St Andrew's House. On the right-hand side of these steps is a plaque known as the Singers' Memorial. The singers concerned are John Wilson, John Templeton and David Kennedy, all of whom, if only remembered today in this plaque, established international reputations for themselves and began their musical careers in Edinburgh.

18. CANAAN LANE, EH9

On the east side of the southern end of Morningside Road are a number of roads with biblical names. The area was formerly part of an estate usually known as 'the Land of Canaan'. Among these names are Canaan Lane, Jordan Lane, Nile Grove, Egypt Mews and Eden Lane. Running along the southern extremity of this area is the Jordan Burn.

There must be a word for the study of street names (suggestions on a postcard please), but there is clearly an underlying theme to this curious collection of names. Explanations vary. Frequently, in Edinburgh and elsewhere, urban street names reflect the interests of former large landowners or developers, their titles, the names of their wives and children and other landholdings they may have had. One only has to think of the large crop of 'Warriston' names in EH3. These names in the Land of Canaan are clearly very different and one suggestion is that there was once a community of gypsies of Egyptian origin in the area, arriving perhaps in the sixteenth century, and that these names reflect their presence.

19. CANDLEMAKER ROW, EH1

Where Candlemaker Row, sloping up from the Grassmarket, meets George IV Bridge stands the famous life-size sculpture known far and wide as 'Greyfriars Bobby'. It was originally paid for as part of a drinking fountain by the extraordinarily rich and deeply eccentric Lady Burdett-Coutts in 1873. The fountain unfortunately no longer works. The story, of which there are several roughly similar versions, tells us that Bobby was a Skye Terrier (or a West Highland Terrier, according to some) who belonged to a local watchman (policeman?) called John Gray, who died in 1858 and was buried in Greyfriars Kirkyard. So devoted was Bobby to his master that he took up his station next to Gray's grave and remained there for fourteen years, come rain or shine, until his own death. It was said that you could set your watch by Bobby, who at exactly one o'clock everyday made his way to a nearby restaurant or pub where the kindly owner had a dish of tasty comestibles waiting for him.

Ghost Advertisement, Candlemaker Row, EH1. Scarcely noticed given all the attention paid to Greyfriars Bobby close by, this faded example of what used to be quite a common advertising medium is seen here from Greyfriars Kirkyard.

This remarkable doggy, or should we say dogged, devotion was made the subject of a greatly embellished novel and at least two rather sickly films, the first in 1961 and the second in 2006, and the sculpture is one of the best-loved and most visited features on the various Edinburgh tourist trails. The dog himself is buried just inside Greyfriars Kirkyard and many people leave sticks for Bobby to fetch and bones for him to munch by the headstone. If Bobby's soul lives on, it has had plenty of time to ponder on human foolishness and gullibility.

Needless to say, in a world in which almost everything is commodified, a variety of merchandise is available hereabouts based around the Greyfriars Bobby theme. Close by, inevitably, is the Greyfriars Bobby pub. With his weakness for pubs with unique names and signs, the author is inevitably pleased with this pub. It has a small carved dog above the door.

20. CANNONBALL HOUSE, CASTLEHILL, ROYAL MILE, EH1

Just down the hill from the Esplanade, on the south side of Castlehill, is Cannonball House, so named because there is a cannonball rather unobtrusively embedded on the west gable. This is obviously an unusual place to find such a missile and those with romance in their souls declare that it was fired from the castle in 1745, when Bonnie Prince Charlie's force was occupying parts of the city. If so, whoever fired

it was a rotten shot. Others, less given to such flights of fancy, think it was possibly placed there in the nineteenth century as an attraction when the city began to be visited by increasing numbers of tourists.

21. CANONGATE KIRK, CANONGATE, EH8

Set back from the Canongate in its own yard is this curious building, erected in the late 1680s. Its oddest feature is external and easy to see. It is a pair of antlers – these are from the coat-of-arms of the former burgh of Canongate, once proudly independent of Edinburgh. Is this the only church in Britain adorned in this way?

A walk around the yard is a rewarding experience, not least because it contains the grave of one very well-known man of international influence, and another who might have become much better-known had he not died at the age of twenty-three. The first is Adam Smith (1723–90). He was born at Kirkcaldy, and after studying at Glasgow and Oxford settled in Edinburgh when it was at the height of its intellectual eminence; he moved in circles which, for example, included David Hume, the eminent philosopher. In *Inquiry into the Nature and Causes of the Wealth of Nations*, Smith developed the concept of the division of labour as being crucial to an understanding of the economic processes that are part of what later came to be called capitalism. His views have been influential for thinkers on both the left and the right of the political spectrum. Despite, or perhaps because of, his intellectual acumen, Smith was notoriously absent-minded. His monument is by the south-west wall of the kirkyard.

The other is Robert Fergusson (1750–74), the poet. He was born in Edinburgh and died tragically and prematurely after showing huge early promise. Fergusson was a sensitive, vulnerable man who, despite having all the attributes potentially making for social success, began to suffer from severe depressions, later becoming insane after suffering injuries in a fall, possibly while drunk. He died in what was then called the City Bedlam, in Bristo Port. His burial place is by the west wall of the kirkyard. Fergusson's work had a significant influence on Burns, who wrote the epitaph on Fergusson's headstone:

> No sculptured Marble here nor pompous lay,
> No stories urn nor animated bust,
> This simple Stone directs Pale Scotia's way
> To pour her Sorrows o'er her Poet's Dust.

It seems very appropriate that on the pavement of the Canongate, by the entrance to the kirkyard, there is a delightful life-size bronze sculpture of Fergusson.

A little further north is a stone, dated 1766, commemorating the Society of Coach-Drivers. This oddity stands above a common grave containing a number

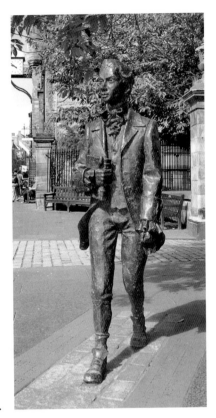

Robert Fergusson statue.

of former members of the society. It is often forgotten that coach-driving was a hazardous occupation. Coaches dashed around at hair-raising speeds, often in complete darkness and with only the most rudimentary breaking systems. Road-traffic accidents were by no means uncommon. Coaches crashed into other road-users, hit obstacles such as fallen trees, slid off icy roads, overturned and, of course, had to run the gauntlet of highway robbers. One coach, admittedly in Wiltshire in England, was attacked by a lion! No wonder coach-drivers formed a society – one of its functions was probably to act as a funeral club.

Buried close to the south end of the kirk is David Rizzio, with only a fairly nondescript small slab to mark his last resting place. Rizzio was of Italian extraction and acted as secretary to Mary, Queen of Scots. As well as being a talented musician, he was erudite, cultured and witty and he and the Queen became close friends, especially when Mary realised what an empty-headed boorish lout she had married in Lord Darnley. Mary craved the intellectual stimulation that Rizzio was able to provide and soon the tongues were wagging to the effect that the couple were not just engaged in intellectual mutual stimulation, but had become lovers. Be that as it may, on 9 March 1566 a group of men, Darnley among them, broke into Mary's chamber in Holyrood Palace and set about stabbing the diminutive

Rizzio to death. Darnley did not take part in this violence, but he did nothing to stop it. The Queen was devastated.

22. CANONGATE TOLBOOTH, CANONGATE, EH8

The Canongate Tolbooth is a very conspicuous building on the north side of the street.

A tolbooth was a kind of multi-purpose municipal building, and this one was the headquarters of the town fathers when Canongate was an independent borough. It had council chambers, a courtroom and a jail. The core of the building, which now houses the People's Story Museum, is probably sixteenth-century, but it has been extensively restored and is now something of a pastiche. It is by no means alone in the Royal Mile in having this attribute. The building has one or two typical Scottish architectural features such as bartizans, which are turrets jutting out from the main building, and a forestair, of which there were once many in the Royal Mile. The outsize clock on its bracket gives the whole building a slightly ridiculous look.

On the south side of the Canongate, almost opposite the Canongate Tolbooth, is Huntly House. This was built in 1570 and was extensively restored in the 1930s. It currently houses the Museum of Edinburgh. For many visitors, the highlight of its collection is the original National Covenant. This was drawn up in 1638 and first signed in Greyfriars Kirk. It was drafted by two devout Presbyterians and copies of it were circulated round Scotland like a petition, gathering large numbers of signatures as it went. The readiness of people to sign it was an indication of the level of popular resentment of the high-handed religious policies Charles I was intending to implement in Scotland and which led to decades of bitter religious strife. Another exhibit of less historical significance is what purports to be the dinner bowl of Greyfriars Bobby.

True to the purpose of this book, however, it is the exterior of Huntly House with which we are concerned. It exhibits half-timbering with plaster infill, and is probably typical of many of the old houses that would once have been found in this quarter. The oddity is a number of Latin phrases visible on its frontage. What they say is doubtless profound or at least thought-provoking, but their impact is largely negated by being rendered in a language to which the bulk of the population never had access. Latin has never been the language of the populace. It is amusing to stand, as the author has done, and hear wiseacres attempting to impress anyone nearby daft enough to be listening by providing a translation of one or more of these phrases. A sense of what one of these means can be provided: '*Constanti pectori, res mortalium umbra*'. No, the author didn't translate this himself, but knows that it is a reference to the essentially ephemeral or insubstantial nature of human existence.

Never mind the Latin, how about this for a source of confusion? In Edinburgh, the gates were called 'ports' and streets with names ending in 'gate', like Canongate, did not have gates. 'Gate' meant something like 'way'.

23. CARDINAL BEATON'S PALACE, JUNCTION OF BLACKFRIARS STREET AND COWGATE, EH1

David Beaton (1494–1546) was a slippery and unscrupulous Roman Catholic prelate far more concerned with secular than with spiritual matters, but always ready to claim divine justification for his actions. When James V died in 1542, Beaton thought his time had come and, having forged legal papers, he 'proved' that he had the legal right to act as senior regent during the minority of the infant Queen Mary. Things did not go according to plan, because the Protestant Earl of Arran was elected regent instead. Beaton was arrested and imprisoned, but it is typical of the man that he somehow managed to get himself released, rehabilitated and then appointed chancellor. In this role he set about avidly persecuting Scottish Protestants, and made himself so unpopular that there was a huge sigh of relief when he was murdered.

His home was in an enclave of Catholic buildings in the Cowgate area and a plaque marks the site, although there is little enough worth commemorating in Beaton's life.

24. CASTLE ESPLANADE, EH1

On the north-west side of Castle Esplanade is a granite monument commemorating Ensign Ewart. Ensigns were the most junior of commissioned officers in the British Army, and this particular ensign of a Scottish regiment made a name for himself by seizing and carrying away a French regimental eagle standard at the Battle of Waterloo in 1815. He only achieved this after literally hacking his way through a mass of enemy soldiers who were rallying in defence of their standard. If his own account is anything to go by, he must have left a trail of dismembered limbs and other bodily parts behind him. Close by a pub is called the Ensign Ewart. It is particularly dear to the author because the name is unique.

A curiosity to be seen on the east side of Castle Esplanade is the Art Nouveau 'Witches' Fountain'. Dating from 1912, it is, or was, a public drinking fountain placed there for the rather odd purpose that when thirsty passers-by were slaking their thirsts, they could be reminded that about 300 people adjudged to be witches were executed close to this spot between 1492 and 1722. In the case of these poor wretches, the word 'execution' is something of a euphemism because they would have suffered all manner of unpleasantness before being dragged to the place of their death. They were tied to a stake and then usually partially strangled before brushwood was placed around them and ignited. If they were lucky, they were dead before the flames started licking their bodies. A plaque provides an explanation and tells us that we should remember that not all witches have been agents of evil. Many used herbal and other natural remedies to heal people. However, those in power have always wanted the common people to have an enemy to act as a focus

for all their pent-up anger and frustration. This was designed to divert attention away from those whose activities created the anger in the first place. Which was, of course, those in power.

25. CASTLEHILL, OLD TOWN, EH1

Those walking up the Royal Mile to the Castle cannot miss the tall and somewhat gaunt Highland Tolbooth St John's Church dominating its surroundings, just below the Castle itself. Designed by Pugin with an eye to authentic architectural detail of the early fourteenth century, it was built in the 1840s. For many years it was unused, a semi-derelict eyesore, but after expensive renovation and conversion, it was reopened in 1999 as 'The Hub', the headquarters of the Edinburgh International Festival. In the road in front of The Hub is a circle of setts which marks the site of the former Weigh House or Butter Tron, where various commodities were formerly weighed and sold.

26. CATHERINE SINCLAIR FOUNTAIN, GOSFORD PLACE, BONNINGTON, EH6

Tucked away inconspicuously in Gosford Place, off Ferry Road, is the Catherine Sinclair Fountain, or at least what is left of it. Catherine Sinclair was a noted nineteenth-century Edinburgh philanthropist who, among other good works, paid for the erection of a public drinking fountain at the junction of Lothian Road and

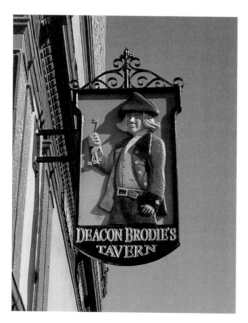

Deacon Brodie's pub sign, Lawnmarket. It is good to find two unique pub names and signs so close to each other.

Princes Street. This provided refreshment for thirsty passers-by and for horses, huge numbers of which dragged loads round the city's streets and were very grateful for the chance to whet their whistles.

Now, there is nothing that local authorities like more than removing obstacles to the free flow of road traffic – they call it progress. As early as 1873, proposals were being made that, because the fountain was causing congestion, it needed to be removed. This decision by the council provoked a storm of protest from its users (not the horses). A surprising number of people seemed to be fond of the fountain as an item of decorative street furniture; others routinely objected to anything the council did or said. The council quickly withdrew its proposal, and it was 1932 before the question of the fountain's removal was back on the agenda. This time, the council moved quickly to pre-empt protest by removing the fountain almost before the ink was dry on the minutes of the relevant meeting. They hid the fountain away in one of their depots after having made a vague promise that it would be relocated. They obviously hoped that the fountain would be forgotten, but from time to time irritating gadflies of the sort to be found in every locality, but especially, perhaps, in Edinburgh, would revive the controversy concerning the fountain. In 1983, a rather pathetic remnant of the fountain was erected on a new site. It no longer functions as a fountain, but neither does it obstruct the traffic. Perhaps this time it will be left alone.

27. CENTRAL BAR, LEITH WALK, EH6

The Central Bar stands at the Foot of Leith Walk. It is a basic pub, typical of those being eased out by Leith's rolling programme of gentrification. Its clientele remains a working class and friendly one, and the pub's interior still retains traces of the opulent furnishings and fittings that were once common in so many of Edinburgh's grander pubs. The pub is the 'Central' because it is built into the frontage of the old Leith Central railway station, originally built by the North British Railway Company. It has a handsome frontage topped by an attractive clock tower. Behind it was the closed station, long used by heroin addicts and providing much of the inspiration for Irvine Welsh's book *Trainspotting* and the subsequent film of that name.

28. CHAMBERLAIN ROAD, EH10

Plague, particularly of the bubonic variety, was a constant visitor to the countries of north-western Europe until the nineteenth century, and mortality rates could reach terrifying proportions. In 1645, the district in which Chamberlain Road now stands bore the full brunt of the plague and among its many victims was one John Livingstone of the Greenhill Estate.

Not cast into a common burial pit like many less well-off citizens, Livingstone was buried in the grounds of Greenhill House and the spot is now marked by a tombstone in a walled-off enclosure in front of the Ashfield Nursing Home.

29. CHARLOTTE SQUARE, NEW TOWN, EH2

In the centre of Charlotte Square, which is in effect an enormous traffic island, stands an equestrian statue of Prince Albert. Born in 1819, Albert of Saxe-Coburg and Gotha was a first cousin to Queen Victoria. Albert was never going to be popular in Britain. It did not help that he was a minor German aristocrat, and a relatively impoverished one at that. Neither did the facts that he was something of an intellectual, totally humourless, quite extraordinarily earnest and well-intentioned, endear him to the people. He was exceedingly prudish, which may not quite fit the image of the couple who successfully procreated as if there was no tomorrow. Albert saw sex as a duty to be carried out in order to ensure that the family line was not in danger of dying out. By all accounts, Victoria was into sex in a big way and found Albert somewhat disappointing in that department. This may account for the fact that she had their bedroom at Osborne House in the Isle of Wight decorated with male nudes. They may have done something for her libido, but Albert disappointed by not always rising to the occasion.

He died, somewhat prematurely, in 1861, and Victoria spent many years wallowing in self-pity and self-indulgent misery, making the lives of all those around her equally miserable.

However, a myth was in the making and statues and other tributes to his memory sprouted up in towns and cities throughout Britain – hence this statue in Charlotte Square.

30. CHURCH HILL THEATRE, MORNINGSIDE ROAD, EH10

The Morningside High (Free) Church opened for services in 1892. It became redundant in 1960 and, after an extensive conversion, reopened in 1965 as the Church Hill Theatre. On the pavement in front of the theatre are two pillars made of granite and bronze with the names of nearby districts of the city and roundels symbolising those districts.

31. CHURCH HILL, EH10

Church Hill is the longer eastward extension of the short Church Hill Place. No. 1 Church Hill bears a plaque to the effect that this was where Thomas Chalmers died in 1847. This simple tablet rather understates a man who was by no means understated in life.

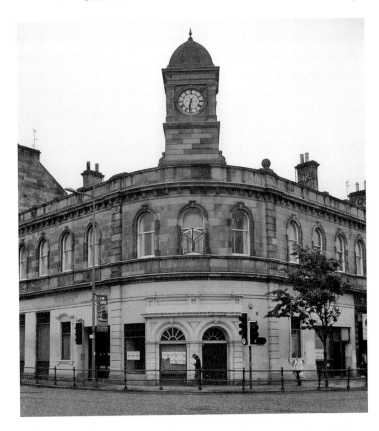

Former Leith Central
station, Leith Walk,
EH6.

The history of the Christian Church in Scotland, as so often elsewhere, is one of discord, disharmony and marked intolerance. In the first half of the nineteenth century, one of the issues at the forefront of acrimonious debate was the practice of the state and certain rich and influential men of sometimes refusing to accept the appointment of ministers democratically elected by a congregation. Chalmers was an outspoken advocate of the Church of Scotland's right to appoint its own ministers. The Government was quite adamant that it must retain control over such matters and the matter came to a head when, in 1843, a large number of its ministers left the Church of Scotland and went off to form the Free Church of Scotland. The repercussions of this schism reverberated around Scotland for generations. Some would say they still do.

32. CITY CHAMBERS, HIGH STREET, EH1

The City Chambers stands on the north side of the High Street, and now contains offices of the City of Edinburgh Council. At one time there was a house on this site belonging to Sir Simon Preston of Craigmillar. A wall plaque near the entry to the chambers relates how Mary, Queen of Scots, spent her final night in Edinburgh after her forces had been defeated at the Battle of Carberry Hill in June 1567. By this time,

Mary was increasingly *persona non grata* in Scotland for a wide variety of reasons, and her enemies conveyed her to house arrest at Lochleven Castle the following day. Life was never to be the same for the beleaguered Queen. Soon afterwards, she escaped from Lochleven and then made what later proved to be the fatal decision to travel to England and throw herself on the mercy of Queen Elizabeth.

33. CLINTON ROAD, CHURCH HILL, EH9

It is possible to catch a glimpse of East Morningside House through the trees. This secluded house probably dates back to the 1720s and, stretching the concept of street furniture to include oddities, as we have been doing, also visible from the road close to the boundary wall is an ancient and gnarled willow tree which is so old that it has to be supported by crutches. It is said that it started as a cutting in a garden in which the woebegone Napoleon Bonaparte whiled away his time during his exile on the remote island of St Helena.

34. COLINTON CHURCHYARD, EH13

Colinton is an affluent Edinburgh suburb through which the Water of Leith flows. The parish church is in Dell Road, and its churchyard is noted for its possession of an unusual mortsafe. This is in the form of a heavy piece of iron shaped rather like a coffin. This device would have been available to hire, and it would have been placed over a freshly-dug grave. It would be left there until such time as the body in the grave underneath had mortified sufficiently to be no longer of interest to the 'resurrection men'. These operators, despised even within the criminal community, needed to carry out their ghoulish work quietly and quickly and would not have been equipped with the gear to move such an obstacle. The mortsafe could later be removed and made available for use elsewhere. It was not cheap to hire one of these devices and therefore class differences existed even among the dead, the graves of the poor being more likely to attract the attention of the resurrectionists. Few such mortsafes have survived. Presumably, the company hiring this one out forgot to retrieve it.

The more common type of mortsafe consisted of heavy iron bars or grills, often around a burial vault, and again the resurrectionists would not have had the time or the equipment to deal with these.

35. CORSTORPHINE VILLAGE, EH12

Near the junction of Dovecot Road and Hall Terrace stands the well-known Corstorphine Sycamore. It is an ancient tree. It is said that in 1679, the tree was the location of a fatal brawl between a drunken debauchee and his lover, ending with her whipping a sword out, running him through and leaving him for dead. The

ghost of this woman, Christian Nimmo, is said occasionally to weep and wail by this tree, as well it might. There is a story that there is treasure buried by this tree but a curse on anyone who tries to find it.

Just along Dovecot Road is a circular doocot built in the sixteenth century and of such massive construction that it looks as if it could withstand a siege.

36. CRAIGLOCKHART CASTLE, GLENLOCKHART ROAD, EH14

Edinburgh Napier University makes something of a speciality of building its campuses around or near castles. This castle is easily visible from the road and consists of a ruined square keep of the thirteenth century or possibly earlier. There is perhaps more congruence between modern higher education and castles than might at first appear, especially in the case of Napier. This university built its reputation on being at the forefront of technological development. Castles only survived as viable defensive bastions if they too embraced the constant development and innovation involved in siege technology and the similar processes in the corresponding technology of defence and the countering of sieges.

The main buildings at the Craiglockhart Campus are well worth a look. They consist of an impressive block which started out as the Craiglockhart Hydropathic Hospital in 1880 and went on, from 1917, to become a military hospital attempting to put some semblance of order and sanity back into the lives of shell-shocked and otherwise traumatised officers who had seen active service in the First World War. Among its most distinguished patients were the poets Siegfried Sassoon and Wilfred Owen. Later, this complex became a convent before, in 1985, being bought up by Napier University.

37. DAVIDSON'S MAINS, EH4

Close to the entrance to Davidson's Mains Park at the end of Main Street stands a cute little stone building about ten feet tall with a domed top and mock castellations. It housed the village well. Before water pipes were invented, just about every settlement had its well or pump. They gave access to underground water supplies and were obviously a necessity of life, which is why they were often treated with great respect and reverence. Constant supplies of pure water were often seen as being miraculous, and therefore wells frequently had religious associations. Most of these facilities have fallen into disuse over the last 150 or more years.

38. DEAN BRIDGE, EH4

Viewed from the Water of Leith Walkway down below, the Dean Bridge looks awesome. It was opened in 1832 to give access from the city to undeveloped

Cow in Cowgate, EH1. The Cowgate was long one of Edinburgh's more notorious streets, and it still has its moments. Gloomy by day and somewhat menacing after dark, Cowgate is becoming a focus of the city's vibrant nightlife. On the south side of the street, a nightspot displays this cow entering the frontage in an unorthodox fashion. The front portion of a cow is leaving the side elevation of the building with equal unorthodoxy.

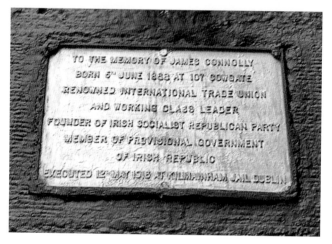

Plaque to James Connolly. Born in the Cowgate district of Edinburgh in 1868, Connolly was a leading activist and fighter for socialism in the American and Irish labour movements. He was one of the leaders of the Easter Rising in Ireland in 1916. The plaque is under the South Bridge.

tracts of land to the north-west which had hitherto effectively been remote from Edinburgh because of the difficulty of negotiating the deep ravine through which the river runs.

The designer was Thomas Telford (1757–1834), the eminent Scottish civil engineer, occasionally referred to as 'the Colossus of Roads'. It was completed in 1831. The bridge in its original state proved too much of a temptation for those Edinborians of suicidal tendency, and the parapets were therefore eventually raised to make jumping off the bridge a more difficult proposition.

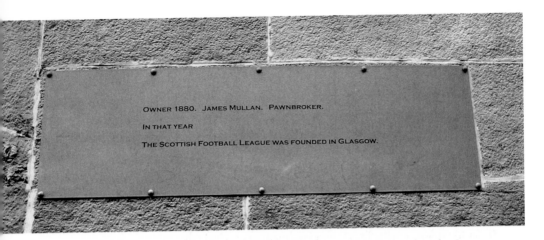

OWNER 1880. JAMES MULLAN. PAWNBROKER.

IN THAT YEAR

THE SCOTTISH FOOTBALL LEAGUE WAS FOUNDED IN GLASGOW.

Bannerman's, Cowgate. 'Bannerman's' is a well-known and long-established pub in the Cowgate. On an outer wall there is a curious but interesting series of plaques giving the date when new landlords took over and citing a well-known historical event of that year.

39. DEAN CEMETERY, DEAN VILLAGE, EH12

A notable Edinburgh dynasty was the Nasmyth family. They are remembered in this cemetery by a fine cross and a family tomb. Alexander Nasmyth (1758–1840) was a successful engineer and painter. Patrick (1787–1831) was another painter and James Nasmyth (1808–90) invented a very successful steam hammer used in forges and ironworks.

Also to be found in Dean Cemetery is the burial place of Dr Joseph Bell (1837–91). He was the professor of clinical surgery in the University of Edinburgh when Arthur Conan Doyle was studying medicine. Doyle was fascinated by the way in which Bell could deduce a large amount about a patient who had just been admitted simply by a careful examination of his or her appearance – and that was before starting a medical diagnosis. Bell had trained himself in the skills of observation and deduction and he encouraged his students to develop the same skills. Sometimes, to amuse but also to instruct his students, Bell would gather them to look out of the window of the lecture theatre, whereupon he would then subject one or more unsuspecting idlers or passers-by to a rigorous scrutiny which would reveal much about their class, their occupation, their preferences and habits simply by the systematic exercise of his well-honed observational skills.

Doyle was so impressed by this facility of Bell's that it went into the make-up of his immortal creation, the detective Sherlock Holmes, a somewhat ascetic, cold, single-minded and dispassionate man who took Bell's methods and raised them almost to the level of a science, much to the awed admiration of his dogged, faithful but perhaps somewhat pedestrian companion, Dr Watson.

One of the most interesting people to be interred in this cemetery is Major-General Sir Hector MacDonald. He is buried in the north-east corner, adjacent to Ravelston Terrace. An obelisk and bronze bust marks the spot. He was born in 1853 and (apparently) died in 1903. He was that rare creature, a man of proletarian origins who rose to almost the highest rank in the army officer corps. His career reads like something out of a 'penny dreadful', as he went around biffing the Boers and crushing those natives in various countries of the Empire who dared to object to British rule, gaining promotion and picking up gongs as he went. Truly he was a popular hero and was commonly known as 'Fighting Mac' but, perhaps inevitably, he made many enemies among his fellow-officers and during a period when he was serving in Ceylon, rumours began to circulate that he was having homosexual relationships with native boys. The truth of this was never established because MacDonald committed suicide in a Paris hotel. Then another series of rumours broke cover, to the effect that he had been living a double life and was actually Count von Mackensen, a senior officer in the Prussian Army who, it was said, had died on the same day as MacDonald.

40. DEAN VILLAGE, BAXTER'S TOLBOOTH, EH4

It is extraordinary to find such a village as Dean in a dramatic setting so close to the perpetual hubbub of the West End. Formerly, Dean was an industrial settlement with several watermills which made use of the Water of Leith to generate their power. Flour was milled and bread was baked and the baxters, or bakers, became a powerful guild in the city. A conspicuous building in the village at the bottom of Bell's Brae is the baxter's tollbooth, on which can be seen inscriptions such as 'God's providence is our inheritance' and 'God bless the Baxters of Edinburgh who built this house 1675'. There are also signs symbolic of the baxters' trade. They include crossed peels, which are the long-handed shovels used to remove bread from the oven.

Close by in the appropriately named Millers Row, three grindstones can be seen adjacent to the former Lindsay's Mill.

41. DOMINION CINEMA, NEWBATTLE TERRACE, EH10

Deep in Edinburgh's southern suburbs is the well-known Dominion Cinema. This opened for business on 31 December 1938 and has continued in business ever since, except for periods involving rebuilding or refurbishment.

The architect of the Dominion was T. Bowhill Gibson, who had much experience in designing such buildings, and here he produced a striking work in what can loosely be described as Art Deco style. The Odeon group of cinemas gave architect Harry Weedon many commissions and the Art Deco style was almost a trademark of the ompany in the 1930s. The style was copied by other companies during this

heyday of the cinema. Externally, the buildings were eye-catching and tended to dominate their surroundings. From the street there was a touch of the dashing contemporary transatlantic liners about these cinemas, while inside the furnishings and fittings were plush and luxurious. For many, the 1930s was a period of economic difficulty and such cinemas provided their patrons with a sense of being able to escape reality for a couple of hours in well-heated, comfortable and opulent surroundings.

The Dominion is remarkable in having always been privately owned. It has carefully kept pace with the times and now has four studios, the largest of which can seat almost 600 and the smallest less than fifty. It is a Category B listed building and its striking appearance (not to everyone's taste) forms a piquant contrast to the sedate, not to say rather prim, medium-sized terrace dwellings next door in Newbattle Terrace, which are more typical of Edinburgh.

42. DUDDINGSTON KIRKYARD, EH8

Edinburgh's tradition as a centre of learning meant that it attracted young men wishing to train to be physicians and surgeons. The university provided lectures and tuition, and so did various freelance teachers and demonstrators. Cadavers were needed for demonstration purposes and for students to work on to develop their practical skills. The supply of legal cadavers was limited, and demand upped the price. Criminals are opportunists and men who were not squeamish and quite content to be numbered among the low-life of the underworld seized an opportunity and started to exhume freshly buried bodies. These enterprising gentlemen were usually referred to as 'resurrectionists' or 'sack-'em-up men' and they descended, like ghouls, on burial places during the hours of darkness, opened up fresh graves, removed the contents, carried them off on carts and sold them to the less scrupulous of the teachers of medicine and anatomy. They could command high prices.

Few cemeteries around Edinburgh were free from the depredations of the resurrectionists, but there were some precautions that could be taken. At Duddingston, a small tower stands near the entrance to the kirkyard and it acted as a watchtower. A cadaver was only useful to the lecturers while it was comparatively fresh, and so a watch would be maintained over a fresh burial for a few days until it was deemed no longer to be of interest to the resurrectionists. They usually worked only in the cooler months of the year because the process of putrefaction soon rendered a corpse unusable when the weather was hot.

On the right of the gate into the kirkyard is a mounting block to enable less agile people to get into the saddle. In these parts, these features were often referred to as 'loupin'-on stanes'. Also of interest and attached to the wall close by is the 'joug's collar'. This fitted around the neck of a minor local miscreant, who would then be attached to the wall and find him or herself subjected to abuse

The Dominion Cinema.

and ridicule by the parishioners. Ironically, failure to attend divine service was one of the offences which might be punished in this way. Not much forgiveness there, then.

43. DUDDINGSTON, SHEEP HEID INN, EH8

Given how close it is to the centre of Edinburgh, Duddingston Village is remarkably rustic and peaceful. The inn, although reconstructed, is possibly the oldest in Scotland and it gets its name from a sustaining broth it used to serve based on a boiled sheep's head. There are other explanations of the pub's name. Various illustrious people are supposed to have obtained refreshment and sustenance in the pub. They include Mary, Queen of Scots, but the idea of her popping in for a wee heavy doesn't sound too likely.

This pub, in its felicitous situation, makes an ideal watering hole for those engaged on a ramble around or over Arthur's Seat. It does good beer, good food and it even has that great rarity these days, a working bowling alley.

Round the corner from the pub, in The Causeway, stands 'Bonnie Prince Charlie's House'. Here, the prince stayed the night before he went forth and did battle with the English at Prestonpans. He met with success on this occasion, the date being 21 September 1745. A plaque above the door sums up these stirring events.

44. DUNCAN STREET, EH9

An imposing building in this street in Newington is the former premises of the world-famous company of map-makers, Messrs John Bartholomew & Son. The most striking feature is the Palladian frontage with its pillars, and a plaque informs the observer that this frontage was removed from Falcon Hall, a mansion in Morningside, which had been the residence of the pioneer cartographer,

Mounting block, Duddingston Kirkyard, EH15.

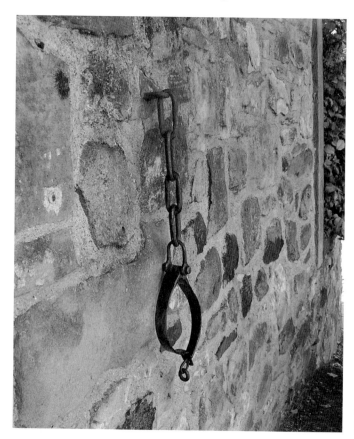

'Joug's Collar',
Duddingston Kirkyard.

John G. Bartholomew. Another plaque outlines the priceless contribution made by the Bartholomew family to the art and science of cartography over a period of more than 200 years. The building now makes a very fitting location for the Edinburgh Geographical Institute.

45. EARL HAIG STATUE, CASTLE ESPLANADE, OLD TOWN, EH1

Douglas, 1st Earl Haig (1861–1928), was born at No. 24 Charlotte Square in the New Town, a member of the whisky-distilling dynasty. He led the British Expeditionary Force on the Western Front from 1915 until the end of the Great War and took part in such epic struggles as the Battle of the Somme and the Third Battle of Ypres. He was never far away from controversy, continually falling out with military colleagues and with politicians, especially Lloyd George. It was widely accepted that he was stubborn, opinionated, inflexible and intolerant. He claimed divine assistance in the tactical decisions he made, but several historians have accused him of being wedded to such outdated tactics that he was almost criminally prodigal with the lives of the men under

The former premises of Messrs John Bartholomew & Son, the internationally known map-makers in the Newington district.

his command, who were forced out of the trenches and over the top to face certain death. The American General Pershing, on the other hand, called him 'the man who won the war'.

When the war was over, he devoted himself to providing financial and other assistance to ex-servicemen, and to the creation of the British Legion. His critics said he did this to salve his guilty conscience. Be that as it may, he is remembered by a fine equestrian statue in a heroic style close to the entrance of the Castle. He was, of course, an Edinborian by birth.

46. EDEN LANE, EH10

Tucked away on the south side of Newbattle Terrace, Eden Lane is a quiet backwater in which a small building rather like a hermitage can be seen opposite one of the entrances to Harmony House. There have always been peculiar people who for entirely irrational reasons best known to themselves have believed that they were doing God's work by isolating themselves in remote places far from their fellows and living lives of the utmost austerity while devoting their time to prayer

and meditation. Their reclusive existence may have been one way of expressing their rejection of the materialism and other wicked ways of mankind, but it is noticeable that most hermits depended on other people to provide the wherewithal for their admittedly frugal existence.

The jury is probably out on whether this was ever actually a hermit's cell, but the walker should not leave Eden Lane without looking at the bricked-up doorways and windows along the wall, which are thought to be the last remaining evidence of ancient cottages once on this site.

47. EDINBURGH ZOO, CORSTORPHINE, EH12

This book does not normally penetrate into places where entry is by payment, but the author decided to make an exception for the magnificent wrought-iron gates and their fine accompanying stone pillars surmounted by falcons which can be seen at the zoo. These were once true street furniture because they could be found on the east side of Morningside Road, opposite Springvalley Gardens. They were the gates to Falcon Hall, one of the district's erstwhile mansions.

48. ELM ROW, LEITH WALK, EH7

On the east side of the top end of Leith Walk, Elm Row, a number of larger than life bronze pigeons stand on the pavement, intended to introduce an element of tranquillity and sanity to the constant bedlam created by the traffic that is a feature of this part of the city.

Anyone who loves food cannot come away from Elm Row without visiting and making purchases at Valvona & Crolla's delicatessen. Although it hardly constitutes a piece of street furniture, this shop has definitely carved a niche for itself in Edinburgh. It is a cornucopia of mouth-watering gastronomic delights, drawing the author in like a moth to a flame.

49. ESKSIDE WEST, MUSSELBURGH, EH21

It is certainly abusing the concept of street furniture to include a gazebo, but we haven't had one before so here goes. This one can be seen from the street and is a fine example of its kind and stands in a particularly delightful part of the town, overlooking the river.

50. FETTES ROW AND DUNDAS STREET, EH3

In 1696, William III needed to raise money to pay for the wars he was involving the country in, and a new source of revenue was found by the cunning device of

Gazebo, Musselburgh.

taxing window glass on all those houses that had more than six windows. This tax was even more unpopular than taxes generally are, and various ways were found to evade it. Some householders simply bricked up the window apertures in order to reduce the number of windows, although this obviously had the disadvantage of making the rooms dark and also often unhealthy, because less or indeed no sunlight or air penetrated the rooms affected. So it is that old houses are often seen with 'blind windows' blocked up to avoid the tax and never restored to their original condition. However, on the basis that things are often not what they seem, some dwellings appear to have blind windows but in fact never had glass in the apertures concerned. They were built from the start with bricked-up windows to maintain symmetry, and the author suspects that this is the case with some buildings in the New Town such as those at the junction of Fettes Row and Dundas Street. In some places, the bricked-up windows were made to look like windows by the painting of imitation glazing bars.

The hated tax was withdrawn in 1851.

51. FORREST ROAD, EH1

New items of street furniture are forever being invented and let loose to create even more clutter in our streets. Among the younger generations of street furniture are machines such as that in Forrest Road which dispenses bus tickets, the intention being to save time paying the driver while getting onto the bus. These machines have of course to be of sturdy construction, given the temptation they provide for opportunistic scallywags to get at their contents.

It was much more fun when buses had conductors and an open platform at the rear. The author remembers lung-busting and sometimes successful sprints down streets after a retreating bus, culminating in a manic leap onto the platform, often to the accompaniment of admiring comments from the conductor and interested passengers. The open platform also had the advantage that passengers could get off between stops, something done when the vehicle was moving fairly slowly in heavy traffic or approaching a bus stop. This form of egress was not without its hazards.

52. FRASERS, NO. 145 PRINCES STREET, EH2

At the west end of Princes Street, the clock on the outside of Frasers is a conspicuous landmark. As this clock strikes the hours and half-hours, a group of Scots pipers in their tartan finery rotates on a circular track. This bit of fun used to be even merrier because a burst of music accompanied the journey of the pipers. Now, they rotate in silence.

53. GEORGE IV STATUE, JUNCTION OF GEORGE STREET AND HANOVER STREET, EH2

There have been several British monarchs of dubious distinction, but few were nincompoops on the scale of George IV. He reigned from 1821 to 1830, having spent many frustrating years officiating as regent in the shadow of his father, who was afflicted by periodic bouts of insanity. During George IV's brief reign, a prime minister was assassinated, a foreign secretary committed suicide, a plot to murder the entire Cabinet was foiled, and an army of spies and agents provocateurs was created to counter growing public demands for political and other reforms. While he was acting as regent just before his father died, unarmed women and children and other protestors were cut down with sabres by militiamen on horseback in the ironically named Peterloo Massacre in Manchester.

Few monarchs have ever led such an active sex life. He lost his virginity at the age of sixteen to one of the Queen's maids of honour and then embarked on a single-minded and relentless pursuit of the opposite sex. He had innumerable mistresses

Blind windows in the New Town.

Iron bollard, Fleshmarket Close, Old Town. Bollards come in several shapes, many sizes and a variety of materials. Motorists dislike them because their presence can prevent them from driving wherever they feel like going, something for which pedestrians should be extremely thankful. If someone was to set up a Bollard Appreciation Society to care for weary or neglected bollards and to encourage the installation of increasing numbers of new bollards, the author would sign up immediately. Let's hear it for the bollards!

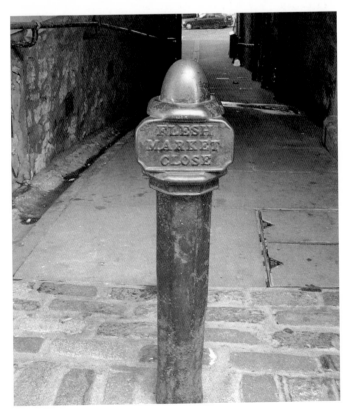

A wyvern in the
Grange district.

and fathered many illegitimate children; he contracted an illicit marriage with a
woman of the Roman Catholic faith who presented him with ten children, and a
legal marriage with Caroline of Brunswick-Wolfenbüttel. She smelt horrible and
was no oil painting, and she and George loathed each other at first sight. It was
only with considerable reluctance on both sides and some time after the wedding
ceremony that the marriage was consummated. George had spent the wedding
night asleep in a drunken stupor and with his head in the fireplace of the couple's
bedchamber. He felt happier there than in the marital bed.

George was pathologically incapable of fidelity. He was also careless of matters
of state, self-indulgent, weak-minded, lazy and ill-tempered and he subjected some
of the women in his life to physical violence. For much of the time he could not
bother to get out of bed, even to deal with important political and other issues. He
was vain and he tried, totally unsuccessfully as it happened, to hide his growing
corpulence by wearing corsets. His lifestyle caught up with him, and he was
seriously debilitated during his latter years.

Four Georges ruled the Union from 1714 to 1830. None of them really won the
hearts and minds of their subjects. The poet Walter Savage Landor (1775–1864)
penned an appropriately savage epitaph on the Georges:

I sing the Georges four,
For Providence could stand no more.
Some say that far the worst
of all was George the First.
But yet by some 'tis reckoned
That worse still was George the Second.
And what mortal ever heard,
Any good of George the Third?
When George the Fourth from earth descended,
Thank God the line of Georges ended.

The sober *Dictionary of National Biography* summed him up: 'There have been many more wicked kings in English history, but none so unredeemed by any signal greatness or virtue.'

An obvious question to ask is why such a booby as George should be remembered in public statuary. The statue was erected in 1831, very quickly after he went to meet his maker. Perhaps the statue was a celebration of his death rather a commemoration of his life.

54. GEORGE SQUARE, EH8

George Square has suffered greatly by its proximity to, and later absorption into, the great wen of the University of Edinburgh. It is highly ironic given the university's international reputation for academic excellence and the city's wealth of fine and elegant architecture that in its process of replacing earlier buildings and in its expansion, the university should be responsible for the ruthless demolition of much that, if not of outstanding quality, was notable and consistent with the city's building traditions. It was the university that totally wrecked the integrity of Buccleuch Place just round the corner by partial demolition and the building of the library, a concrete and glass high-rise monstrosity monumentally insensitive to its surroundings.

Of George Square itself, little has managed to avoid the vandalising attentions of the university, although the west side of the square remains and is of interest to the walker because it contains a seemly terrace of two- or three-storey eighteenth-century stone town houses. Similar buildings would once have made up the other three sides of the square, which was built in 1760. It was a planned development, evidence of how Edinburgh was expanding southwards from the Old Town, and it was not named after the king of the time but the elder brother of the architect and developer James Brown. It anticipated in concept the much larger and grander development of the New Town some years later, but was almost revolutionary by the standards of Edinburgh because of the idea that

each house in the square should be occupied by a single family. Edinburgh at that time was characterised by high-rise tenements with common stairs and multiple occupancy of each block. It was a kind of layer cake in which the poorer classes lived in the lower storeys and the social status of the residents rose the higher up the building you went.

No. 25, which still stands, was home to Sir Walter Scott for many years. In its early years, before the development of the New Town started in earnest, George Square was a highly prestigious residential address providing, for those who could afford it, an escape from the overcrowding, the noise, the squalor and the stench of the Old Town. As the rich moved out of the Old Town, the environmental decay became even worse, with even greater overcrowding among the inhabitants, who were almost uniformly poor.

55. GEORGE STREET, NOS 82-4, EH2

Not too many lighthouses can be seen on the streets of Britain's towns and cities, but a rather fine, albeit miniature, one can be seen on the front of nos 82–4 George Street. This building houses the Northern Lighthouse Board, which looks after the lighthouses along the Scottish coast, on the various Scottish offshore islands and the Isle of Man. The lighthouse works! It would, however, make a poor marine navigational aid, being located where it is.

Elsewhere (see page 95), the author alludes to female breasts and he trusts that no reader will think that he is obsessive about such items if he visits the theme twice. No. 1 George Street is the premises of Standard Life Investments, and it displays a frieze with bare-breasted young women who are so like each other that they could be taken for identical quintuplets. The frieze was made in 1975 and is a visual reference to the story in the Bible of the Wise and the Foolish Virgins. The implication, of course, is that to place one's investments with Standard Life is to be like the Wise Virgins and therefore to make sensible provision for the future.

56. GILMERTON COVE, DRUM STREET, GILMERTON, EH17

Near the junction of Gilmerton Road with Newtoft Street is Gilmerton Cove. This was once a smiddy, with accompanying living quarters for the blacksmith, but what is remarkable is that it stood on a site hacked out of solid sandstone. This back-breaking task seems to have been carried out in the early 1720s by George Paterson, who was the village smith.

57. GILMERTON ROAD, NETHER LIBERTON, EH17

Near the northern end of Gilmerton Road stands the Nether Liberton doocot. This provides eloquent testimony to the importance of the pigeon in the lives of our ancestors. More than 400 years old, it is probably the largest ever built in the Edinburgh area and provided a cosy home for over 2,000 birds, plus a lot of grief for farmers of arable land in the vicinity.

58. GOLFER'S LAND, CANONGATE, EH8

Golfer's Land, on the north side of Canongate, was the home of John Paterson in the seventeenth century, he being an early devotee of the emerging game of golf. A cluster of plaques tells the story of a round of golf he played with the Duke of York in the 1680s and provides various other pieces of historical information.

59. GRANGE COURT, CAUSEWAYSIDE, EH9

Through a pend, or arched entry, off Causewayside is a fine example of careful urban renewal, worth having a quick look at. On this site, many small old houses with outside stairs had fallen into serious disrepair and were prime candidates for demolition a few decades ago. Instead, they were thoroughly modernised and renovated and some additional new dwellings were erected. Old houses of character were therefore kept, and their replacement by characterless new buildings was avoided.

60. GRANGE CEMETERY, EH9

Grange Cemetery stands in the lush, plush suburbs of the Southside. As is only to be expected, it contains the graves and often the accompanying memorials of the kind of people that Edinburgh has produced, or who have come to be associated with it, in such large numbers. They include men and women of letters, theologians, publishers, travellers, engineers and doctors. Perhaps it is unusual, given the presence of such illustrious neighbours, to find two graves which recall the darker side of Edinburgh's history.

Along the wall of the cemetery which abuts onto Lovers' Loan is the grave of Mary Jane Pritchard and her mother and father. She was the victim of a poisoner who was a doctor and also just happened to be her husband.

In the annals of crime, there seems to be a disproportionate number of doctors who have been murderers and many of them have used poison to achieve their ends. Dr Edward William Pritchard qualified in medicine and surgery in 1846, married Mary Jane Taylor in 1850 and bought a practice in Edinburgh in 1859. He was an ambitious man who not only wanted to rise in his profession, but also

to become a prominent public figure. He did indeed make a name for himself, but not in the way he intended.

Pritchard first came to the attention of the authorities when, in May 1863, a fire partly destroyed the attic of his house in Glasgow. The charred, dead body of the family maid was found in the burnt-out room. At first, it looked as though she had been reading in bed by the light of a candle which had somehow ignited the bed clothes. Investigating officers then began to become suspicious about some questions that needed answering. Was there a link between the girl's death and the fact that, although unmarried, she was pregnant? Was it just coincidence that the fire had started when Pritchard was the only other person in the house, his wife being away with her parents in Edinburgh? Why was the girl's bedroom door locked from the outside?

The police surmised that Pritchard was the father of the unborn child and that because, for many reasons, he did not want it, he had murdered the mother-to-be. He had the motive, the means and the opportunity. Perhaps he had brought her a nightcap containing a powerful sedative, watched her fall asleep, set fire to the bed clothes and then left the room, locking the door as he went. Proving it was another matter, but there was no smoke without fire and Pritchard received much hostile publicity which badly affected his medical practice. He got into debt and moved across Glasgow to another district, where he hoped the scandal and gossip would not follow. Soon, he was philandering again. He obviously regarded serving girls as fair game. This time his victim was only fifteen and when she became pregnant, he performed an abortion. His wife found out what he had been up to and gave her husband a piece of her mind. A few days later, she became chronically ill with severe vomiting and diarrhoea and she was despatched home to Edinburgh, where her parents could look after her.

She made a partial recovery and returned to Glasgow, only to be taken so ill again that her mother came from Edinburgh to nurse her. Mrs Taylor was now certain that foul play was involved when she, her daughter and the cook all became violently ill after eating tapioca pudding. First the old lady died, closely followed by her daughter. Pritchard had poisoned them with a mixture of aconite and antimony salts. This time there was no escape for Pritchard. He was found guilty and hanged at Glasgow on 28 July 1865. Over 100,000 people turned out to watch him die in what was Scotland's last public hanging.

Near the southern wall of the cemetery is a monument marking the resting place of Elizabeth Chantrelle (1851–78). Eugene Marie Chantrelle was a handsome Frenchman who arrived in Edinburgh in 1866 to begin a new life. As well as being good-looking, he was charming, plausible and stimulating company and he used these qualities to good effect in the serial seduction of attractive young women. He gave private tuition and this of course provided a ready supply of women, many of them chaste, clearly a condition which he relished terminating. Among these young women was Elizabeth Dyer. Having had his fun, he was then greatly irritated

to find that she was pregnant. Reluctantly he found himself being manoeuvred into matrimony, a blessed state for which he was most definitely not yet ready. He became violent towards Elizabeth and was drinking heavily and consorting with some of Edinburgh's most depraved women. His business as a tutor went to rack and ruin and he found himself in severe financial difficulties. Unknown to Elizabeth, he took out an insurance policy on her life and murdered her, making it appear as if she had been overcome by gas fumes. His trial lasted four days and, having been found guilty, he was hanged at Calton Jail on 31 May 1878.

61. GRANGE LOAN, EH9

In ecclesiastical terms, a grange was an outlying farmhouse with agricultural land belonging to a monastic establishment and one of the sources of wealth of that establishment. The present-day district of Grange originally constituted the grange of St Giles in the Old Town, but it actually was under the control of Holm Cultram Abbey in what was formerly Cumberland. Much of the land in Grange eventually came to be owned by the occupants of Grange House, who built an enormous turreted mansion close to Grange Loan. Along this attractive road and easy to miss are two stone pillars topped by what are supposed to be griffins, but were mistakenly carved as wyverns. This is perhaps a forgivable mistake for the carver in view of the fact that both creatures are entirely fabulous, and he therefore could never have seen either. A griffin was part lion and part eagle, supposedly combining the qualities of the lion as the king of beasts and the eagle as the king of the birds. The wyvern, by contrast, was a flying serpent something like a dragon, possessing two legs like those an eagle, a forked tongue and a tail equipped with barbs.

This may be too much information, but the wyverns masquerading as griffins were a heraldic charge of the Lauder family, who at one time occupied Grange House. The columns acted as boundary markers for the eastern and western extremities of their estate.

62. GRASSMARKET, OLD TOWN, EH1

At the east end of the Grassmarket some pink setts in the form of a cross of St Andrew indicate the site of the former gallows, the final execution at this spot being in 1784. Close by is the unusually and ironically named Last Drop Tavern. It may be that condemned prisoners were allowed a swift dram or two in the pub to provide them with some Dutch courage before they went to meet their maker.

It would not be unfair to say that Edinburgh has had a turbulent history, and in that history the Grassmarket has often been the scene of major mayhem. Perhaps the most famous occasion was the Porteous Riot of 1736. A large mob crowded into the Grassmarket, angry about the hanging of a local smuggler – smugglers

frequently enjoyed considerable popularity. Their activities enabled people to buy taxable goods at a knock-down price because no duty had been paid on them. Anger broke out into violence and some of the crowd surged forward, attempting to prevent the hanging. Porteous, the captain of the guard, panicked and ordered his men to fire into the crowd. Six people died. Porteous was arrested, tried and found guilty but when it was announced that he had been officially pardoned, this was seen as the last straw. The mob broke into the Tolbooth and dragged Porteous out, hanging him in the Grassmarket. He is buried in Greyfriars Kirkyard. No one was called to account for his death.

The Grassmarket was originally Edinburgh's main market for the buying and selling of agricultural produce, but it was also important as a hub of the old coaching industry and one of the inns involved in this trade, the White Hart, is still trading today – without the coaches, of course. It is only in the last twenty years that the Grassmarket has managed to slough off its reputation as one of the seediest and most threatening parts of central Edinburgh.

63. GRAVEYARDS AND CEMETERIES

Edinburgh is well supplied with graveyards, many of which provide congenial centres of greenery and tranquillity in the city and fine places for walkers. They also contain a cross-section of the mortal remains of the remarkably large number of men and women who, whether good or bad, have been associated with the city and made a mark on the world into which they were born. To get the most out of a walk around a burial place, however, is not just to read the inscriptions on headstones, wonder at the cock-eyed reasoning behind the ostentatious memorials of the rich and powerful or simply wallow in a strange mixture of pleasant melancholia tinged, perhaps, with morbidity brought on by simply being alive in the middle of so much evidence of mortality. Greater enjoyment can be had by understanding the symbolism of so much of the funerary art of the past. This art can provide intriguing insights into the cultural values that responded to different periods of economic and social activity. The great days of funerary art were from the sixteenth to the nineteenth century – Reformation the to Enlightenment and the Industrial Revolution, it might be said.

What follows are a few comments about some of the carving, statuary and symbols which may be encountered among the older burials in Edinburgh's graveyards. Perhaps the most interesting are those which are emblems of mortality or immortality, and these are rarely found after the eighteenth century.

A Death's head is a perfect example of *memento mori*, a reminder to the observer that he or she will die. Death's heads frequently gnaw bones or are accompanied by crossed bones. Sometimes the death's head lacks a lower jaw, or it may have deep eye sockets to add to the dramatic effect. Skeletons often appear in a recumbent position,

perhaps resting on an elbow, and they symbolise the passive, indiscriminating and inevitable nature of death. Where a skeleton is standing up, it is often accompanied by darts, spears or scythes, which are weapons of Death, and the skeleton represents Death as the king of terrors. Snakes, sometimes with apples in their mouths or next to a tree, symbolise Sin and Death. Father Time was a common motif, and he usually appeared with a scythe and hour-glass to suggest to us that time was not on the side of the observer. Hourglasses were often portrayed by themselves and they represent the passing of time. Sexton's tools, consisting of a spade and mattock, are usually crossed, while trees with branches lopped off symbolise the shortness of life on Earth. Torches, pointing downwards and extinguished, indicate death. Decorative urns became popular in the nineteenth century for their symbolic association with death. Crosses appeared in large numbers as funerary architecture, and broken columns sprouted up in burial places, suggestive of life being cut off. All these motifs were indicative of mortality.

Emblems of immortality were likewise numerous. Cherubs represent winged souls leaving the body at death. If the souls were lucky they went straight into heaven, but most of them would have to hover around waiting for the Day of Judgement, when their fate would be decided. Angels, usually wearing loose robes, symbolise the Resurrection. Naked, stylised humans indicate bodies whose souls have already left, rising from their graves to be judged.

Sunbursts represent the glory of God, while lit torches pointing up suggest eternal life. Hearts symbolise the soul, and a heart pierced with one or more arrows or darts stands for death. Palm leaves and laurel leaves, on the other hand, are indicative of victory over death. Scales signify the weighing of souls on the Day of Judgement, when the soul's fate might go either way.

A number of emblems may be found displayed in old graveyards and most of these, while often being decorative, frequently have symbolic significance. Lilies suggest purity; scallops are associated with pilgrimage; anchors are indicative of hope; doves represent the Holy Spirit; hands appear in various guises, but usually representing prayer; the phoenix denotes rebirth and the pelican suggests purity.

64. GREYFRIARS KIRK AND KIRKYARD, EH1

Tucked away through a narrow entrance behind buildings opposite the Museum of Scotland is a church surrounded by its yard, the two together constituting one of the most historic sites in Edinburgh. We do not deal with architectural history and detail in this volume but suffice it to say that externally the Kirk has a strange appearance, difficult to date – not surprising given its turbulent history, which has included destruction by fire and, more unusually, explosion. Consequently, it is an architectural hodge-podge and a not particularly attractive one. It stands on the site of a Franciscan friary, hence its name.

For the perambulator in search of the curious and atmospheric, the kirkyard has a lot to offer. Many of Edinburgh's rich and influential citizens are buried here, as well as some of her scapegraces, and near the entrance there is a handy information board providing a key to the locations of their graves. There is a wealth of funerary sculpture, *memento mori* and even a few devices of iron, rather like mortsafes, designed to guard the contents of the vaults of the rich; all grist to the mill for those who like to study past attitudes towards death.

To the north-east of the church is the unmarked burial site of the author's favourite occupant of the Greyfriars Kirkyard. This is William McGonagall (1825?–1902), who is quite possibly the worst poet ever to have seriously put pen to paper. He would probably have been consigned to total obscurity had not his work been 'rediscovered' in the post-war period by a number of comedians, including Spike Milligan and Billy Connolly. Mocked and derided by the public in his time and scoffed at by the critics, he has now become a cult figure and has many affectionate devotees. He has many websites devoted to him; such is the nature of posthumous recognition in the age of electronics. There is even a move afoot to have his eccentric genius commemorated on a postage stamp!

He was born in the Cowgate of a poor family of Irish immigrants and died there, still in poverty. Inbetween times, he was brought up in the Orkneys and then became a weaver in Dundee. He did some amateur acting (very badly) before taking up the poetic muse, equally badly. He wrote poetry which is totally inimitable. It is a mixture of banality, bathos, irrelevance, inept rhyming and confused scansion, and he gave recitals of his works in pubs and clubs in Scotland's towns and cities. He became well-known and very much in demand but, lacking as he did even a vestigial sense of humour, he could not for the life of him understand why it was that his audiences, instead of listening with rapt and admiring attention, rolled about on the floor in uncontrollable paroxysms of helpless mirth, tears coursing down their faces while they suffered agonising stomach pains caused by their surfeit of laughter. Either that or they pelted him with any missiles that came to hand, preferably dried peas.

McGonagall styled himself a poet and tragedian; his output was enormous and he had a particular penchant for writing about disasters, death and funerals, as well as royalty and famous people, whom he was sure would be greatly flattered to be the object of his lyrical attention. He was a militant advocate of temperance, and so included moral tales in verse about the evils of the demon drink in his repertoire. It was such items that often provoked the peas.

Affecting the long hair and generally bohemian appearance he thought his profession of poet and tragedian warranted, McGonagall took himself unbelievably seriously. It is somehow typical of the man that he was the victim of a cruel practical joke when he was informed that an eastern potentate had graciously seen fit to bestow on him the honour of becoming a Knight of the White Elephant, and that he could henceforth

style himself Sir William Topaz McGonagall, Knight of the White Elephant, Burmah. McGonagall fell for this jape hook, line and sinker and only regarded recognition from such a distant place as his due and as evidence that his fame was spreading. It is impossible to leave him without a short excerpt from his work, to give a flavour of his unique style for those who have not had the good fortune to come across his work before. These are some verses from 'Beautiful Rothesay':

> Beautiful Rothesay, your scenery is most grand,
> You cannot be surpassed in fair Scotland.
> 'Tis healthy for holiday makers, to go there,
> For the benefit of their health, by inhaling the pure air.
>
> And to hear the innocent birds, on a fine Summer day,
> Carolling their sweet songs, so lively and gay,
> Therefore, holiday makers, be advised by me
> And visit beautiful Rothesay, by the side of the sea.
>
> Then sweet Jessie, let us go,
> To Scotland's garden of Eden O!
> And spend the lovely Summer day,
> In the beautiful village of Rothesay.
>
> There you can see the ships, passing to and fro,
> Which will drive away dull care and woe,
> And, the heavens breath smells wooingly there,
> Therefore, let's away, sweet Jessie, to inhale the balmy air ...

McGonagall died where he was born, in the Cowgate, and still in poverty.

Between the middle of the sixteenth century and 1900, almost 100,000 people were laid to rest at Greyfriars. This caused severe overcrowding, and Robert Louis Stevenson was given reason to comment on the large number of well-fed, complacent-looking cats that seemed to treat the place as home.

Attempting to decipher the inscriptions on old headstones is a popular exercise. Some of the inscriptions can be highly amusing, if only because of the cringing eulogies which make it seem extraordinary that those whose praises are sung at such great length could ever managed to have got into their coffins, so huge must have been their halos. One such epitaph to be found in Greyfriars Kirkyard gives a flavour:

Alexander Monteith, druggist in Edinburgh, a man remarkably distinguished by true greatness of soul, and by far the most eminent in the surgical art – whose sepulchral mound might be termed a pile of virtues, the lofty eulogies upon which, pronounced

on the non-professional, and contained in all the foregoing epitaphs, unless they were confined within their own lines and limits ... He departed this life on December 23rd 1713, two days before the festival of the birth of Christ, lest the mourning and the sadness on account of the decease of the former might interrupt the joy and exultation of the nativity of the latter.

This is a somewhat abbreviated version, but the verbosity, obscurity of expression and fawning obsequiousness make it typical of its kind.

65. HEART OF MIDLOTHIAN, HIGH STREET, OLD TOWN, EH1

Close to the main entrance to St Giles Kirk, set in the pavement in pieces of brass, is the well-known Heart of Midlothian. This marks the site of the former tolbooth. This dated from 1561 and originated as a customs house where local merchants and others paid tolls. It subsequently had other uses, including acting as a prison and place of execution. It was a noted and conspicuous landmark in the Old Town, and for that reason it was adorned from time to time by the severed heads of particularly notorious executed convicts. These heads were supposed to act as a salutary warning against the wages of sin but were actually a popular attraction, fascinating young and old alike. The tolbooth was demolished in 1817.

There is a tradition that spitting on the Heart of Midlothian brings good luck. You may see others do so, but the readers of this book are likely to be far too fastidious to engage in such an unhygienic practice.

66. HERIOT ROW, NEW TOWN, EH3

No. 17 Heriot Row was the home of Robert Louis Stevenson (1850–94), although he was born at 8 Howard Place. Never a healthy man, he was extremely skinny and stooped and affected a bohemian appearance. He is best-known for his classic adventure stories such as *Treasure Island, Kidnapped* and *The Strange Case of Dr Jekyll and Mr Hyde*, but he also wrote many short stories, essays and travel pieces. He died and was buried in Samoa, of all places, where he had gone in a vain attempt to improve his health.

67. HERMITAGE OF BRAID, EH16

Edinburgh is exceptionally fortunate in the amount of green space which can be enjoyed by the public within the city's limits. The Hermitage of Braid is one such delightful piece of greenery, and it has a footpath alongside the Braid Burn in the southern suburbs. This path is approached from Braid Road, which is off Comiston Road.

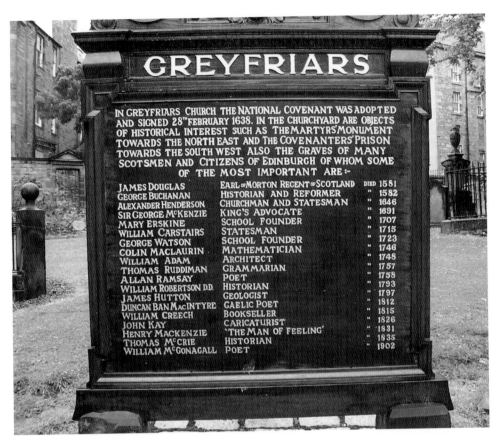

GREYFRIARS

IN GREYFRIARS CHURCH THE NATIONAL COVENANT WAS ADOPTED AND SIGNED 28TH FEBRUARY 1638. IN THE CHURCHYARD ARE OBJECTS OF HISTORICAL INTEREST SUCH AS THE MARTYRS' MONUMENT TOWARDS THE NORTH EAST AND THE COVENANTERS' PRISON TOWARDS THE SOUTH WEST ALSO THE GRAVES OF MANY SCOTSMEN AND CITIZENS OF EDINBURGH OF WHOM SOME OF THE MOST IMPORTANT ARE:—

JAMES DOUGLAS	EARL OF MORTON REGENT OF SCOTLAND	DIED	1581
GEORGE BUCHANAN	HISTORIAN AND REFORMER	"	1582
ALEXANDER HENDERSON	CHURCHMAN AND STATESMAN	"	1646
SIR GEORGE McKENZIE	KING'S ADVOCATE	"	1691
MARY ERSKINE	SCHOOL FOUNDER	"	1707
WILLIAM CARSTAIRS	STATESMAN	"	1715
GEORGE WATSON	SCHOOL FOUNDER	"	1723
COLIN MACLAURIN	MATHEMATICIAN	"	1746
WILLIAM ADAM	ARCHITECT	"	1748
THOMAS RUDDIMAN	GRAMMARIAN	"	1757
ALLAN RAMSAY	POET	"	1758
WILLIAM ROBERTSON D.D.	HISTORIAN	"	1793
JAMES HUTTON	GEOLOGIST	"	1797
DUNCAN BAN MacINTYRE	GAELIC POET	"	1812
WILLIAM CREECH	BOOKSELLER	"	1815
JOHN KAY	CARICATURIST	"	1826
HENRY MACKENZIE	'THE MAN OF FEELING'	"	1831
THOMAS McCRIE	HISTORIAN	"	1835
WILLIAM McGONAGALL	POET	"	1902

Greyfriars Kirkyard. This board helps the lazy or those of a nervous disposition who don't fancy penetrating the remoter parts of the burial ground.

On the north side of the burn, a dovecote, or doocot, can be seen. This served a small castle which was formerly situated close by. It dates from the seventeenth century and is a reminder of just how important pigeons were to our ancestors. They kept pigeons to provide meat, particularly through the winter, when little alternative fresh meat was available, and also eggs. With their unique homing instinct, they also played an important role as a communications medium, carrying messages in both peace and war. A less well-known use of pigeons was for medicinal purposes. People suffering from 'melancholia', which was a kind of catchall word for anything from depression to headaches and hangovers, were recommended to cut a live pigeon in half and apply it to the head or, alternatively, to the soles of the feet. Pigeon blood was thought to sooth sore and bloodshot eyes, and gastric upsets were treated by swallowing a drink containing the dried and powdered lining of a pigeon's stomach. People suffering from gout and baldness were recommended to rub themselves with a mixture of pigeon dung and watercress. Pigeons were also the unfortunate victims in the sport of falconry. Large dovecotes could house a thousand or more birds.

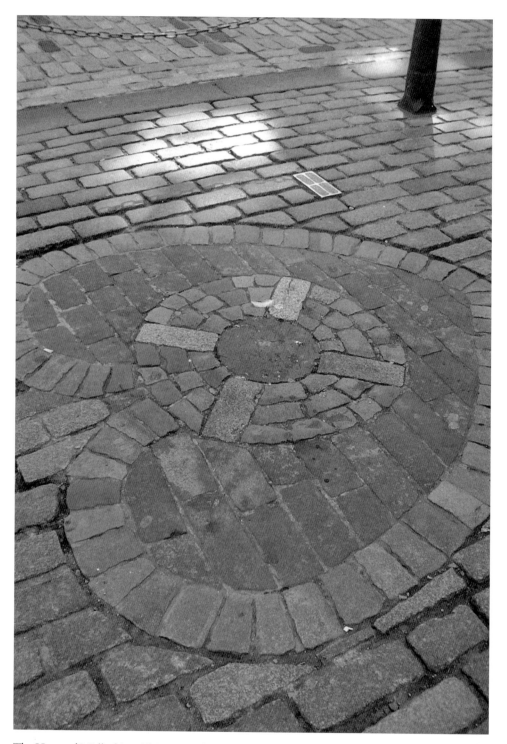

The Heart of Midlothian. This unusual item of street furniture is now firmly part of Edinburgh's culture. At one time, there was even an express train running to and from London called *The Heart of Midlothian*!

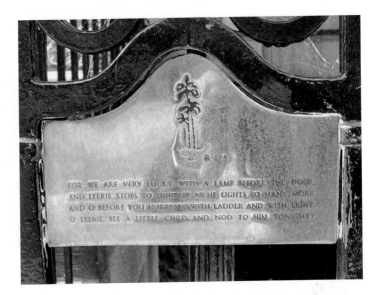

FOR WE ARE VERY LUCKY WITH A LAMP BEFORE THE DOOR
AND LEERIE STOPS TO LIGHT IT AS HE LIGHTS SO MANY MORE
AND O! BEFORE YOU HURRY BY WITH LADDER AND WITH LIGHT.
O LEERIE. SEE A LITTLE CHILD. AND NOD TO HIM TONIGHT!

Plaque in Heriot
Row to Robert Louis
Stevenson.

A little further along on the south side of the path is an ice house, another reminder of culinary practices of the past. These buildings were designed to store ice in bulk for summertime use in the days before refrigeration was available. Ice packed tightly together in blocks has a relatively small surface in relation to its mass and under normal conditions melts quite slowly. A mass of ice lasts even longer when protected by insulated walls and a roof – hence the invention of the icehouse. It is even better if at least some of the building is underground. Icehouses were probably introduced to Britain in the seventeenth century. By the mid-nineteenth century, large numbers of country houses possessed one or more icehouses on the estate. They could also be found in the basements of town houses. The normal practice was to store ice that formed on local rivers and ponds but later, ice started to be imported in bulk in the nineteenth century, especially from Scandinavia.

At the entrance to the Hermitage in Braid Road there is an attractive small toll house which formerly stood at the southern end of Morningside Road. When tolls were abolished in the 1880s, this building was taken down and re-erected on this new site.

68. HIGH STREET, ST MARY'S STREET AND JEFFREY STREET, CANONGATE, EH8

At this intersection at the bottom of the High Street, a number of brass slabs are set into the roadway. They mark the site of the Netherbow Port, one of six former gates guarding entrances through the city walls. This gateway had, as might well be expected, a chequered history. Erected in 1513, it was demolished by the English in 1544, but was soon rebuilt and lasted until 1764, when it was knocked down for the

equivalent of road widening. Like the Old Tolbooth, its prominent position meant that the severed heads of those who had got on the wrong side of authority were often exhibited there, and they of course attracted the appalled fascination of all who passed by. Earlier, in 1745, it had been the means by which Bonnie Prince Charlie's force had gained entrance to the city. They may have entered the city, but they were unable to contemplate storming the strongly-defended Castle with its English garrison.

69. HIGH STREET, TRON KIRK, EH1

A conspicuous landmark in the High Street is the Tron Kirk, which is based around a seventeenth-century church with a later spire, replacing one which disappeared in a fire. The building of this church was started after Charles I grossly offended the Scots with his ill-considered attempt to impose episcopalism on the Scottish Church. Most of the congregation of St Giles's had walked out in disgust and decided to build a church of their own, unsullied by the stupidities the King was so keen on. It was completed in 1647.

This church gained its name because in front of it was placed a 'tron', a set of public weighing scales. These went out of use in the eighteenth century, while the church ceased to be a place of worship more recently. It is now a tourist information centre. For many years, the Tron Kirk acted as a focus for the Hogmanay revels which are taken so seriously in Edinburgh, but now spectacles like the firework display in Princes Gardens have largely directed these festivities elsewhere.

70. 'HOLY CORNER', EH10

This busy road intersection is where Colinton Road, Morningside Road and Chamberlain Road meet, and it has its nickname because at one time four churches, belonging to different denominations, stood at this point. They belonged to the Church of Scotland, Scottish Episcopalian, Congregationalist and Baptist groupings and were witness to the complete inability of the followers of Jesus Christ to come to any accord with each other as to how exactly they should worship Him.

71. HOWARD PLACE, CANONMILLS, EH3

Robert Louis Stevenson was born at No. 8 Howard Place and spent his very early years there. In 1947, the Hopetoun Press of Edinburgh brought out an edition of his *A Child's Garden of Verses*. Stevenson had a remarkable facility for being able to understand and express the mindset of a child and the poems are a delight. However, what made this edition even more delightful were the numerous wood engravings by Joan Hassall. One of these accompanies the poem 'The Lamplighter'. In this poem, the child relates how he watches 'Leerie' – all lamplighters were called

'Leerie' – going about his work and he yearns to be a lamplighter himself when he grows up. A wonderfully atmospheric engraving accompanies the poem, showing items of street furniture such as a gas lamp on the corner, iron railings at the front of the house, a drain cover and even a coalhole cover. It would be nice to think that Hassall took her inspiration from Howard Place.

72. JOCK'S LODGE, EH7

In Restalrig Road South, off London Road, is a remnant of the former Restalrig Kirk, and close by stands St Triduana's Well. There is no history of Triduana, otherwise known as Tradwell, only legends, although of the fact that she lived, there is little doubt. She may have been born in Turkey in the fourth century and with St Rule, or Regulus, she is supposed to have bought relics associated with the apostle St Andrew to Scotland. The town of St Andrews is thought to have developed into a place of pilgrimage because believers came to respect and revere these relics, and were willing to part with good money for the privilege of doing so.

Triduana was a woman of unassailable chastity and probity. She was also a most toothsome maiden. A Scottish prince is supposed to have fallen for her and wooed her with the usual heady mixture of lust and love. He told her that she had the most wonderful eyes he had ever seen. He promised her the world if only he could get to know her better. She saw through this flattery, told him so and rather melodramatically she then flounced off, took an instrument and gouged her own eyes out. These she then had delivered to the prince. This unexpected gesture broke the prince's resolve. He realised that Triduana was something of a drama queen and he rapidly went off her, especially because she now no longer had at least two of the special features which had so captivated his heart in the first place.

Anyway, in due course Triduana's relics gravitated to Restalrig, next to a well which her presence was thought to have sanctified. The water was reckoned efficacious for those suffering from afflictions of the eye and many were drawn to Restalrig to seek relief. However, in December 1560, this idolatrous practice was condemned by the Protestant reformers and the relics were dispersed, the saintly cult destroyed and the buildings demolished. What can be seen now may include some of the original fabric in a partial restoration.

73. JOHN KNOX HOUSE, HIGH STREET, EH1

This building may be pre-sixteenth-century, and there does not seem to be any real connection with John Knox. On a corner is a sundial surmounted by a bearded and hirsute figure who might be taken to be John Knox, but is actually supposed

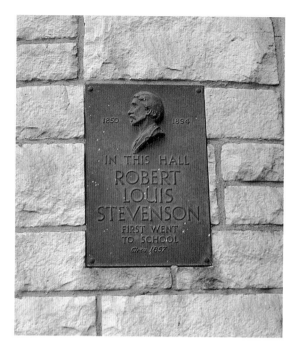

Plaque to Robert Louis Stevenson,
Canonmills.

to be Moses. He is gazing upwards and pointing to a sun emerging from a cloud. The sun bears the word 'God' in three languages. Although heavily restored, this building gives a good impression of Edinburgh's town houses of the past.

74. JORDAN BURN, EH9 AND EH10

The Jordan Burn may now be an inconsiderable stream, but it has had a historic impact out of proportion to its size. It seems to rise just north of Craiglockhart, and it runs in a roughly easterly direction through Morningside and Blackford before joining the Braid Burn not far from Cameron Toll. Although it mostly runs underground, it is visible, for example, in the Blackford Avenue area. It has carved out sufficient of a valley for it to provide a natural route for the Edinburgh South Suburban Line, which, although it lost its passenger services many years ago, remains *in situ* for other traffic. The burn also formed the southern boundary of Edinburgh until 1856. Natural features such as rivers were often used as demarcating lines for administrative purposes.

This rather surreptitious little stream, or perhaps a tributary of it such as the Comiston Burn, has a piece of street furniture devoted to it. This is in the entry between Maxwell Street and Millar Place and consists of an iron grille through which, at quiet times, the burbling of the burn may be heard. Those with nothing better to do are advised to make their way there after constant heavy rain. Good listening!

More spectacular evidence of the existence of the stream can be seen at nos 356–60, on the west side of Morningside Road, where the storeys above the ground floor of the tenements had to be demolished because the flow of the Jordan Burn was undermining the foundations and rendering them unsafe.

On some maps, the Jordan Burn is marked as the 'Pow Burn', its old name.

75. KIRKBRAE HOUSE, DEAN BRIDGE, EH4

At the south end of Dean Bridge and the top of Bell Brae stands this curious little building, an eclectic mishmash that has been added to piecemeal over the centuries, and consequently defies adequate description. For many years it was the base of a horse cab company. The owner of this operation, as he got older, became increasingly cantankerous and unwilling to venture out of his comfort zone, which consisted of sitting, wrapped in blankets in cold weather, puffing on a malodorous, tar-encrusted old briar pipe and telling enquirers that he had no equipage available, even when one or more were evident. Despite this unhelpful attitude, he became something of a local landmark and people would go and ask for a cab when they had absolutely no intention of using one, even if it was available for hire.

On the outside of Kirkbrae House can be seen a sundial and a number of sculpted stone panels removed from other buildings. These only add to the general effect of quirkiness.

76. LANARK ROAD AND SLATEFORD ROAD, EH17

The Edinburgh and Glasgow Union Canal, usually known as the Union Canal, was built to connect the Forth and Clyde Canal at Falkirk to Edinburgh, and it was completed in 1822. Among those who laboured in its building were the soon-to-be notorious Burke and Hare. It is just over 31 miles long, although it once extended a short distance further towards the centre of Edinburgh. Its main purpose was to transport coal in bulk to Edinburgh, and to reduce the cost of this vital fuel for industrial and domestic consumers in the city. It went out of commercial use in the 1930s, but has been revived as a much-appreciated recreational facility. Walkers find it a haven of tranquillity and those coming out of Edinburgh will see, on Viewforth Bridge, the second bridge going westwards, the coats of arms of the cities of Edinburgh and Glasgow.

The canal crosses the A70, close to its junction with Craiglockhart Avenue, on a spectacular concrete aqueduct called Prince Charlie's Bridge. Nearby, a plaque explains that it is close to the spot where Bonnie Prince Charlie's army briefly halted before moving on to occupy Edinburgh. The concrete aqueduct replaced the original stone structure in 1937. The latter had to go. It was narrow, and was increasingly obstructing the traffic in the busy road below.

Missing tenement, Morningside Road.

77. LAURISTON PLACE AND LAWSON STREET EH1

The headquarters of the fire service in Edinburgh is in Lauriston Place, and the early years of a public fire service in the city are synonymous with the name of James Braidwood (1800–61). In 1824, Edinburgh was wracked by a series of major fires which destroyed a large part of the Old Town. The brigades operated by various insurance companies were unable to fight the fires successfully and the decision was taken that a professional, well-trained and well-equipped municipal fire-fighting force was an urgent necessity.

The man appointed to command this force was locally born James Braidwood. He was a hard taskmaster in terms of the training and discipline he required of his men, but even with limited funds, to him goes the credit for quickly welding together an effective fire-fighting force in a city notorious for its many fires. Braidwood, who seems to have engendered respect wherever he went, studied fires, how they started and how they spread, and invented many innovative items of fire-fighting equipment. He also wrote extensively on the subject and when, in 1832, a vacancy arose for the post of Superintendent of the London Fire Engine Establishment, he had no hesitation in leaving Edinburgh for the metropolis, where he immediately forged an equally impressive and efficient unit. He died leading his

men in their battle to subdue a massive conflagration in riverside wharves close to London Bridge.

A plaque to Braidwood can be seen on the frontage of the Fire Brigade Headquarters in Lauriston Place. It is entirely appropriate that Braidwood's selfless endeavours and personal courage should also be celebrated by a plaque at No. 33 Tooley Street, London SE1, close to where he died. This is possibly the oldest commemorative plaque in London.

78. LAWNMARKET, GLADSTONE'S LAND, EH1

Gladstone's Land is not a piece of real estate that belonged to the famous British Prime Minister of the nineteenth century. It is a building with parts dating back to at least the sixteenth century, and at one time it was owned by a family with the name of Gledstanes. A 'Land' in Scottish terminology is a tenement or block of flats. Gladstone's Land, having once been a prime candidate for demolition, was expensively restored and is now a museum. It retains a forestair, once a very common feature of the buildings in the Old Town.

The front of the building sports a rather fine golden hawk, this being a rebus, or visual pun: a 'gled' was Scottish dialect for a hawk.

79. LEITH STREET, EH7

On the east side of Leith Street, close to the top of Broughton Street, two large model giraffes stand on the pavement and form an attractive talking point. They are absolutely no use and yet they are fun and, of course, they are definitely street furniture.

80. LETTER BOXES

These very familiar items of street furniture have their devotees, some of whom belong to the Letter Box Study Group. What its members don't know about letter boxes is simply not worth knowing. Lamp letter boxes (attached to a pole or upright of some sort) and wall boxes are usually rural or at least suburban phenomena, but in Edinburgh the free-standing pillar box reigns supreme in the city streets.

Letter boxes erected in Scotland during the reign of the present queen do not bear the royal cipher exhibited by boxes elsewhere in the United Kingdom. Many Scottish people felt very strongly that this queen was not Queen Elizabeth II of Scotland, the thrones not having been united until the death of Elizabeth I of England in 1603 and the accession to the English throne as James I, the reigning James VI of Scotland. Feelings ran so high that newly installed boxes with the

AYE READY

In memory of JAMES BRAIDWOOD, first Master of Fire Engines in Edinburgh and founder of the British Fire Service, born in Edinburgh in 1800, who died whilst fighting a fire in Tooley Street, London in 1861.

'Aye, Ready' Plaque, Lauriston Place.

cipher of Elizabeth II were in some cases vandalised and sabotaged. For that reason, letter boxes of all types made for use in Scotland bear only the representation of the Scottish crown and they omit the royal cipher.

Dean Village can still boast a working Victorian letter box. It is often forgotten that letter boxes suffer wear and tear and do not last forever, so one that dates back to Victorian times has definitely given good value for money.

81. LOTHIAN ROAD, NO. 165, EH1

No. 165 Lothian Road houses the Fountainbridge branch of Lloyds TSB. In the entrance to the banking hall is a mosaic with the words, 'Thrift is Blessing'. These are words spoken by Shylock, the Jewish moneylender in Shakespeare's play *The Merchant of Venice*.

There is something of an irony in this quotation being where it is, in view of the problems foisted on the world in recent years by the banking fraternity which, far from encouraging thrift, urged people on to ever more reckless borrowing.

82. MERCHISTON CASTLE, COLINTON ROAD, EH11

This typical small Scottish tower-house has had curiosity thrust on it rather than being born with it as such. It consists of a strongly built fifteenth-century building of four storeys and an L-plan. It has a corbelled-out parapet and clearly the building would have had some defensive capability. It is only to be expected that it had a violent and chequered history, but by the 1950s it was derelict and a candidate for

Right: Giraffes walking tall.

Below: Former North Leith station, Commercial Street, EH6. The still-extant frontage of the former North Leith station of the North British Railway. The railway network serving Leith was a complex one and it only served to confuse because just a stone's throw away from the North British station was Leith North, operated by its deadly rival, the Caledonian Railway Company. The building shown here houses a boy's club.

Links Place, Leith, EH6. Is this a ship's figurehead protruding from the front of the building? If not, what is it?

demolition. However, in 1958 it was restored and incorporated into Napier Technical College, now Edinburgh Napier University. With quite extraordinary insensitivity, a corridor of extremely nondescript 1960s-type architecture extrudes from a nearby equally nondescript block and connects with and penetrates the Castle.

Now, the viewer is inclined to feel a little sorry for Merchiston Castle. Did it really deserve this? It is a rose among thorns.

Close by, and also on the north side of Colinton Road, is the Lion Gateway which once marked the entrance to Merchiston Castle. It has two columns, each of which is topped by a lion *couchant*, that is, one which is lying down and taking the weight off its feet. The Lion Gateway formerly stood nearby, but was relocated to this spot in 1964.

83. MINTO STREET, EH9

Minto Street runs along the west side of what were once the grounds of Newington House. This was a substantial mansion, built in 1805 with enough land to allow for the development of a small and select housing development. To keep this development exclusive, gates and porters' lodges were built at the Minto Street and Dalkeith Road ends of Blacket Avenue and Mayfield Terrace respectively. The posts from these gates and the lodges can still be seen. Newington House itself was demolished in 1966.

84. MORNINGSIDE PARISH CHURCH, MORNINGSIDE ROAD, EH10

This redundant church, now occupied by Napier University, stands at the junction with Newbattle Terrace. It has a prominent clock which, despite never telling the

Victorian pillar box, Holyrood Park Road.

time, is one of the most familiar and well-loved sights of Morningside. The clock stopped in 1892, and ever since then has resolutely stuck at twenty past four.

85. MORNINGSIDE ROAD, EH10

On the west side of Morningside Road, close to the junction with Morningside Place, a milestone can be seen in the wall. Although the inscription is difficult to decipher, this stone marks a distance of one mile from Tollcross and two miles to Fairmilehead.

Milestones, which come in a bewildering variety of shapes, styles and sizes, are survivors from an age when the pace of life was considerably slower. They have been superseded in the last hundred or more years by the often characterless clutter of information and instructions which makes up a large proportion of today's street furniture and, more recently, by devices such as sat-nav. Milestones came in wood, stone and iron and were features which, at their best, and despite their essentially utilitarian nature, could do something to enhance the street scene. Unfortunately, they have proved to be extremely vulnerable to neglect, traffic

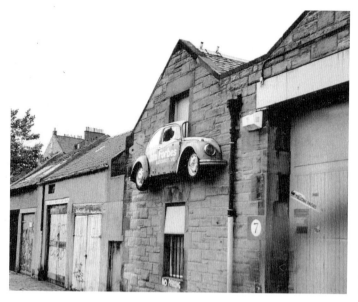

Meadow Lane, EH8. Meadow Lane borders the northern end of The Meadows and until recently provided the odd site of a vertical slice of a VW Beetle attached to the wall of what had probably once been a mews building but was then in use as a workshop largely given over to repairing these characterful little cars.

accidents, road widening and vandalism and, particularly in urban areas, they only remain in greatly reduced numbers.

86. MORNINGSIDE ROAD RAILWAY STATION, EH9

The line passing round the southern suburbs of Edinburgh lost its passenger services in 1962, although the route is still open for other rail-borne traffic. A footbridge crosses the line from Balcarres Street to Maxwell Street, and from this bridge it is possible to see traces of the old Morningside Road station. The bridge has been retained, as it is part of an ancient right-of-way. The original street-level station buildings are still visible, now in use as shops on the west side of Morningside Road.

The line opened in 1884. Much of the early surveying work was carried out by the ill-fated Thomas Bouch. Knighted amid plaudits of admiration for the building of the Tay Bridge, he was execrated when the bridge collapsed during a violent storm at the end of 1879, hurling a train and all its passengers into the river. No one survived. Public opinion rather than scientific and technical objectivity decided that fatal design faults were responsible and Bouch was a broken man, dying less than a year after the fall of the bridge. The unfortunate man is buried in Dean Cemetery.

A landmark in Morningside Road, close to the former station, is a public clock. This has a plaque attached to it which explains that it was presented by three local councillors in 1911.

Morningside Road station. The platform of the closed station can just be seen in the encroaching undergrowth. At one time, the amenities of the station included a 'what the butler saw' machine, technically known as a 'mutoscope'.

87. MOROCCO'S LAND, CANONGATE, EH8

On the north side of Canongate, just east of its junction with Cranston Street, is the building known as Morocco's Land and high up on the front can be made out a Moorish carved figure. The presence of this oddity has given rise to a number of explanations, none of which is totally convincing. One of them relates how a young man of bad character was forced to leave Edinburgh and try to make his way in the world. He got as far as Morocco, and it seems that he prospered. He nursed a burning resentment against the city which he thought had treated him badly when he was young, so – and here comes the silly bit – he assembled a small fleet of ships containing Moorish soldiers and planned

to land them and storm the city. This sounds absurd, and of course it never happened. Then he apparently realised what nice people the Edinburgh folk were after all, and he settled back in the city and went on to become a wealthy and respected citizen.

The building, Morocco's Land, is not the original tenement and the carved curiosity is the only remnant of the former building, which was almost totally rebuilt.

88. NEWHAVEN VILLAGE, EH6

Opposite Newhaven Harbour and close to Pier Place stands a curious tall stone barometer case dating back to 1775 which has around its base the words, 'Society of Free Fishermen'. A building close by was also associated with the society, which was a kind of self-help and mutual benefits organisation. Newhaven was Edinburgh's fishing port, but the fishing ran down and then died out in the last century. The village, although cleaned up and sanitised, has managed to retain much of the appearance of a Scottish fishing village.

At the junction of Annfield Street and Newhaven Road, a memorial to the men of Newhaven who fell in the First World War can be seen built into the wall of a block of tenements. A memorial to the local men and women killed in the Second World War is displayed on the wall of the nearby school, which also proudly shows the words, '1843 Leith School Board 1885'.

Off Newhaven Main Street, at Auchinleck Court, can be seen The Armada Stone. This has been relocated at least twice from older buildings nearby. The stone displays the date 1588, a Latin inscription, the words 'In the Neam [*sic*] of God' and a sixteenth-century sailing ship flying a St Andrew's cross from its main mast.

On Trinity Crescent, the Old Chain Pier pub stands on or close to the site of the Chain Pier, opened in 1821. This was something like a suspension bridge and extended 500 feet out to sea. Initially it served steamers plying to and fro between various ports on the Forth, but it fell into disuse as ships got bigger and needed deeper water in which to berth. The pier then struggled on as a recreational facility until it was destroyed by a severe storm in October 1898.

89. NEWINGTON ROAD, NO. 17, EH9

This is one of a terrace of what must at one time have been quite fashionable and elegant town houses lining this main road southwards out of Edinburgh. Its original name was Arniston Place. Tacky buildings in what once would have been the front garden area of the houses abutting on the road are now filled with shops, restaurants and takeaways.

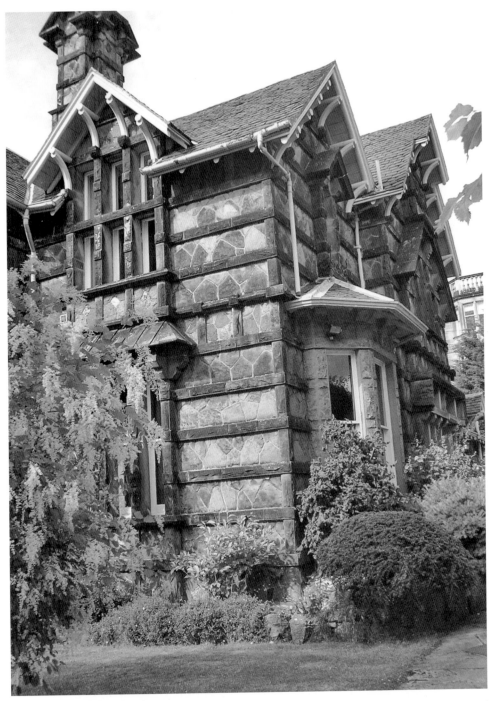

Gothic house, Napier Road, EH10. This part of Merchiston once had a number of mansions of bizarre but imposing appearance designed by local architect Sir James Gowans. The best of them was probably Rockville, demolished amid a storm of protest in 1966. Buildings of such a size have proved to be an endangered species in modern times. Something of their character is hinted at by this much smaller Gothic villa. The author does not know if it was designed by Gowans.

No. 17 is not particularly easy to identify, but it was once occupied by the egregious Dr Knox. In a way, Knox was a victim of his own success because he was by all accounts an absolutely superb lecturer in anatomy and surgery. His popularity meant that he needed more and more cadavers and the supply of legal ones was strictly limited. Nature abhors a vacuum, especially criminal nature sniffing out the possibility of financial reward. It was perhaps inevitable that if Knox let it be known that he was not going to ask any questions, then someone would start supplying him with illegally obtained cadavers.

On 12 February 1829, the serenity of this part of Edinburgh was shattered by the ominous sound of metal implements being rhythmically beaten as a large and angry crowd made its way from the Old Town to Knox's house in Newington Road. A few days earlier, William Burke the bodysnatcher had been publicly hanged in front of a huge crowd who reckoned that Knox was equally guilty, since he had bought the bodies of those that Burke and Hare had murdered in the almost certain knowledge that the corpses had not been obtained by legal means. The ugly mood had not dissipated because it was felt that Knox's superior social status had guaranteed his impunity, so someone's suggestion of going to his house and letting him know exactly what they thought of him caught on like wildfire. This kind of practice, where the crowd let someone know that they had offended against commonly held ideas of what was right and wrong, was known as a 'skimmington' or 'riding stang'. In the event, they stoned Knox's house and hanged an effigy of the man from a convenient nearby tree. They were not to know that Knox had had a prior warning of what was likely to happen and had made sure he was not at home at the time the crowd was expected.

90. NORTH BRIDGE, EH1

This bridge, graceful when seen from a distance, crosses Waverley station and joins the Old Town to the east end of Princes Street. It was built in the 1890s. On the east side of the bridge there is a memorial to the officers and men of the King's Own Scottish Borderers who lost their lives in the Boer War (1899–1902).

91. NORTH FOULIS CLOSE, NO. 299 HIGH STREET, EH8

Standing on the north side of the High Street, No. 299 displays a fine plaque revealing that at one time the premises were occupied by James Gillespie (1726–97), who had a snuff shop. He was a man who cared little for his own appearance or, apparently, for material possessions, but he made a fortune and left large amounts of money for philanthropic purposes. He is buried in Colinton churchyard.

Cast-iron utility cover, Pier Road, EH6. In the old fishing village of Newhaven, now greatly sanitised, there can be seen a number of old cast-iron covers embossed with reminders of a former company of iron-founders at Bo'ness further west along the south shore of the Firth of Forth. The small town of Bo'ness was intensively industrialised, as was much of central Scotland between Edinburgh and Glasgow, a fact becoming less obvious visually year by year. Deindustrialisation is not unique to Scotland and can be found in many parts of the UK. When travelling through some of the former industrial communities, it is easy to wonder what is

92. OBSERVATORY ROAD, EH9

It would be hard to miss the Harrison Arch at the junction of Blackford Avenue and Observatory Road. It is made of dressed red sandstone and is an architectural piece commemorating the life and work of Lord Provost Sir George Harrison (1812–85), whose likeness appears in a bust inside the pediment over the roadway. Harrison had much to do with the acquisition of Blackford Hill as a recreational facility for the people of Edinburgh. An inscription states that Harrison's life was devoted to the public good. There was clearly no intention here that that Harrison's good would be interred with his bones and then forgotten. Blackford Hill is one of Edinburgh's many delightful open spaces and for that we should be grateful.

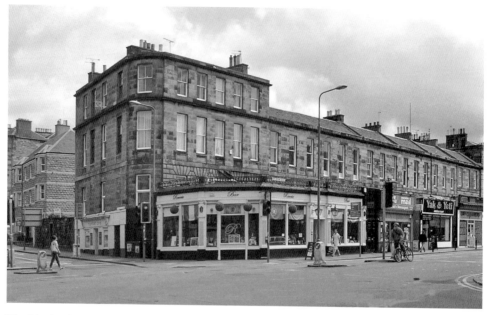

The block of buildings containing No. 17 Newington Road.

93. OLD CALTON BURIAL GROUND, WATERLOO PLACE, CALTON, EH7

This atmospheric cemetery contains several interesting monuments. One is to David Hume (1711–76) the eminent philosopher and historian, born in the city. An oddity is a memorial to Abraham Lincoln for his contribution to the emancipation of the American slaves although, in reality, to him this cause very much took second place to the necessity of keeping the Union together. Quite spectacular is the tall obelisk of the Martyrs' Monument. This commemorates five men, admirers of the slogan of the early French Revolution, liberty, equality and fraternity, who advocated democratic political reforms in the 1790s. The British ruling class had no truck with such subversive nonsense and transported the men to penal servitude at Botany Bay. Despite the fine views and the wealth of interesting monuments and memorials, unfortunately this burial place is not a location in which to linger, especially for any walkers by themselves.

Close by, the New Calton Cemetery also has some illustrious occupants.

94. OLD PLAYHOUSE CLOSE, CANONGATE, EH8

On the south side of Canongate is Old Playhouse Close, and set in the road in front of it is a Maltese Cross marking the spot where another cross used to stand, from which proclamations were made in the days when the Canongate was an independent borough.

Watchtower at Old Calton Cemetery.

95. PAISLEY CLOSE, HIGH STREET, OLD TOWN, EH1

On the north side of the High Street, almost opposite Blackfriars Street, Paisley Close is one of the innumerable wynds in this part of the city. Above the entrance to the wynd, a carved relief can be seen. It commemorates the remarkable fortitude of a youth who would otherwise almost certainly have lived and died in total obscurity.

As mentioned before, fire was a constant danger in the densely packed rabbit warren that was the Old Town, but there were also occasions when badly built or poorly maintained buildings suddenly collapsed, often without warning. Some of them were multi-storey buildings and the toll of death and injury could be a severe one.

In November 1861, nos 99–107 in the High Street collapsed in the early hours of the morning, and thirty-five people were killed. The building concerned was five storeys high, and it simply imploded. Rescuers had a vast pile of rubble and timber to work through and they were soon extracting the bodies of people who had either been crushed or had simply been suffocated. Remarkably, some of the latter were physically unmarked. The rescue operation and the removal of bodies took some time and were hampered by fear that nearby buildings might also collapse. Hope was evaporating that any more survivors would be found when a foot with the toes

moving slightly was revealed. This spurred the rescuers on to greater efforts, and eventually they extracted a teenage lad called Joseph McIver. He was unhurt and, apart from being rather dusty, he bore no signs of the ordeal he had just undergone. What was so remarkable was the cheerful stoicism with which he seemed to handle the traumatic experience. As he was being unearthed, he looked around cheerfully and is purported to have said, 'Heave awa' chaps, I'm no dead yet.'

These upbeat words have been immortalised in the carving above the entrance to Paisley Close, along with a low-relief representation of the resilient McIver himself. The number of deaths resulting from this incident spurred the city authorities on to take a more positive and active approach to inspecting buildings in this part of the city, forcing the demolition of the worst and insisting that necessary repairs were made to others. As for McIver, he had his fifteen minutes of fame.

96. PARLIAMENT SQUARE, OLD TOWN, EH1

The restoration of the monarchy in 1660 in the form of Charles II was generally welcomed in Scotland, and in 1685 the huge equestrian statue that stands in Parliament Square was unveiled. With good reason Charles was known as 'the Merry Monarch', and it is a wonderfully piquant paradox that very close by is the last resting place of John Knox. A coloured square identifies the burial place of Knox – it is under a parking bay.

Charles had at least thirteen mistresses and fathered many illegitimate offspring, some of whom he elevated to the peerage. He was clearly a sexual libertarian and many of his subjects seem to have admired and envied him for his concupiscent athleticism. He got his comeuppance when he contracted a number of sexually transmitted diseases. He was an unashamed hedonist with no trace of hypocrisy. He was also a spendthrift, as were so many other kings and queens – prodigal with what, in effect, was other people's money. He was described as a man of many virtues and many great imperfections. He had a serious side to his character, greatly enjoying art, architecture, music and theatre for example, and was also interested in science – it was he who founded the Royal Society and the Greenwich Observatory. He was witty, kind, good-natured and, by royal standards, very unstuffy. As he lay on his death bed, he apologised to the courtiers and place-seekers crowding the chamber and said, 'I am sorry, gentlemen, for being such a time a-dying.' This, then, is a brief summary of the man represented in the impressive lead statue in the square.

It would be difficult to find another human being more temperamentally different to Charles than John Knox (*c.* 1510–72). He was a determined and domineering clergyman, a magnificent orator and leader of the Scottish Reformation and he is usually regarded as the father of Scottish Presbyterianism. It would not be unfair to say that the popular image of Knox is of a ranting, self-righteous, intolerant bigot and extreme misogynist. This latter characterisation has much to do with his

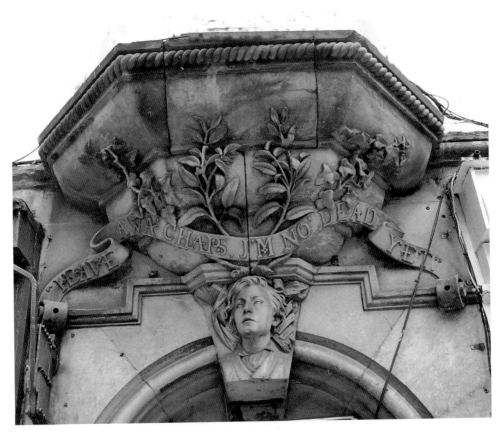

'Heave awa', Lads'.

being the author of *The First Blast of the Trumpet against the Monstrous Regimen of Women*, published in 1558. Although this is often taken to be a denouncement of women in general, its purpose was a diatribe against women monarchs and rulers who were Catholics. In particular, he had in mind Mary, Queen of Scots, and her mother, Mary of Guise. In fact Knox was married twice, enjoying a mutually happy relationship with his first wife and being totally distraught when she died. At the age of fifty, he caused something of a sensation and provoked considerable salacious comment when he remarried, his second wife being a girl of seventeen.

Knox served as minister at St Giles' Kirk from 1560 to 1572, and there is a statue to his memory outside the Faculty of Divinity at the University of Edinburgh. Intolerant and dogmatic he may have been, but Knox contributed to the struggle for human freedom by arguing that the people had the right, and indeed the duty, to rise up and fight unjust or unholy rulers.

97. PARLIAMENT SQUARE, MERCAT CROSS, EH1

A near neighbour of the Merry Monarch is the Mercat Cross. This is relatively modern (it was built in 1885), and replaced a medieval cross which once stood in the middle of the High Street until it was removed and placed near the top of Fleshmarket Close. Although they varied widely in design, many Scottish towns had such crosses and they were used for trading, as meeting places, and as stands from which public proclamations were made. The Mercat Cross shows off a rather nice unicorn, accompanied by the cross of St Andrew.

The unicorn is a fabulous beast often depicted in heraldry and appearing, with variations, in many different cultures across the world. In Western Europe, both the beast and its horn were considered exceptionally rare. The unicorn signified purity and it was said to be able to render water totally pure just by dipping its horn into it. Other beasts got wise to this and would wait to slake their thirst by a watering hole until the unicorn had come along and dipped his horn into it. The unicorn was a dangerous creature, and was hard to capture because it was extremely shy and wary. There was, however, one foolproof way of capturing a unicorn. The difficult bit was the first stage, which involved finding a beautiful young virgin. After that it was plain sailing. The virgin had to be persuaded to go into a lonely forest and sit down, tied to a tree. Any passing unicorn would make a beeline for her, attracted by finding a creature as rare and chaste as itself. It would then meekly lay its head in the virgin's lap, whereupon the clever waiting hunter would leap out from a nearby thicket and deal the unicorn a fatal blow. At least, that's how the story goes.

98. PICARDY PLACE, LEITH WALK, EH1

Picardy Place is not for those rare souls who find their greatest pleasure in silence and repose. It is part of an endlessly busy traffic intersection at the top end of Leith Walk. It has a significant place in the history of popular fiction, and especially the crime genre, however. Here, at No. 11, was born Arthur Conan Doyle (1859–1930), who rose to fame and fortune on the back of his major creation, Sherlock Holmes. But Holmes turned out to be something of a Frankenstein's monster for Doyle. The author became thoroughly disillusioned with churning out stories featuring the single-minded and coolly dispassionate super-sleuth and eventually thought he had disposed of him when his creation fell into the raging Reichenbach Falls in a mutual embrace with his arch-enemy, the scoundrel and blackguard Professor Moriarty. It was not to be. Reluctantly, Doyle was forced to embark on the writing of further stories, such was the popular demand and the pressure of his publisher. Those who really know their Holmes, however, say that while the detective may not actually have died in the Reichenbach Falls, he was never quite the same man after the experience.

Picardy Place contains a statue of Sherlock Holmes. It is a strange world in which we commemorate people who never existed, but then the author has heard people looking at the statue who have said in all seriousness, 'It doesn't look much like him.' What is to be made of that?

In fact, Picardy Place is a little slice of heaven for devotees of sculpture. It houses the Manuscript of Monte Cassino. This is the work of locally born sculptor Sir Eduardo Paolozzi, who died in 2005. It uses elements of the human form to symbolise both the presence in this part of Edinburgh of substantial numbers of people of Italian origin and also the fierce battle that took place at Monte Cassino during the Second World War. It stands to the eternal shame of the British Government that during the war it interned, and even in some cases despatched to Canada, Britons of Italian origin, many of whom had made substantial and beneficial contributions to their communities in Edinburgh and elsewhere.

99. POLICE BOXES

Police boxes are, or were, telephone kiosks located in readily accessible public places and available for members of the public who needed to contact the police. They were also used by officers out on patrol to contact headquarters (or themselves to be contacted *by* headquarters – some of the boxes sported a flashing light). The compartment housing the telephone was only a small part of the installation, and most of them were large enough to have a room which could double as a mini-police station. They have been rendered obsolete over the last forty years by more effective and faster methods of communication. Except in Glasgow, they were painted blue. The first police boxes ever were introduced in the USA in 1877, and their first appearance in the UK was at Glasgow in 1891.

There are still a substantial number of these boxes to be found on the streets of Edinburgh. Most, if not all, are listed buildings and while the majority are disused, some have undergone a new lease of life as small coffee bars. Edinburgh's boxes are of a unique design, quite unlike the 'TARDIS' kind of box that was familiar elsewhere and especially in London. They were rectangular in plan rather than square, and were designed by a local architect, Ebenezer MacRae, who incorporated in their design some minor classical motifs as an acknowledgment of the city's historical heritage, at least that which is incorporated in many of the buildings of the New Town and some of the city's public buildings.

Among the locations where surviving boxes may be found are: Canongate, EH8; Drummond Street, EH8; Grassmarket EH1; Heriot Row, EH3; Lauriston Place, EH3; Lawnmarket, EH1; Melville Drive, EH9; Princes Street; Newhaven Harbour EH6; Richmond Lane, EH8; Tollcross, EH3; and Rutland Square, EH1.

Police box in Lawnmarket,
Old Town.

100. PORTOBELLO, EH15

It is typical of Edinburgh's multi-faceted character that, in Portobello, it possesses its own seaside resort. Probably Portobello as a resort is totally unknown to most English people, but in its prime, which is definitely in the past, not only was it appreciated as a destination for Edinborians bent on harmless pleasures, but it also attracted large numbers of working-class Glaswegians who descended on the town for their short annual holiday.

Portobello's greatest attraction as a seaside resort is still there in all its glory and this, of course, is its spacious sandy beach. The large and rumbustious funfair that brought so much enjoyment to so many and the lido, where so much strutting and posing was carried on and holiday romances were set in motion, are increasingly distant memories for the older generation. Portobello's days as a resort to stay in are long gone, but warm, sunny days in the summer still attract substantial numbers of Edinburgh people, who stroll the sands and the promenade and enjoy their fish and chips.

Evidence of Portobello's past and present as a seaside attraction can never be entirely expunged, but its industrial heritage is already much less obvious. In fact, Portobello was something of a manufacturing centre, noted particularly for its brick and tile-making. Few traces remain, except for two impressive beehive-

Police box with artistic touch, Pleasaunce, EH8.

shaped kilns which were shrouded in scaffolding the last time the author was in Portobello. These kilns creep into the book because, although even the author cannot pretend that they are street furniture, they can be seen from the street and that is good enough for him.

101. PORTOBELLO ROAD, PIERSHILL, EH7

Close to Piershill Cemetery, Craigentinny Crescent leads off the north side of Portobello Road. A little way up the left side of the road is the erection commonly known as the 'Craigentinny Marbles', as it is regarded as Edinburgh's version of the misleadingly named Elgin Marbles. This is the absurdly florid mausoleum of William Henry Miller (1789–1848), who certainly flouted the tendency of Quakers towards a lack of ostentation. He was a wealthy and cultured, if rather eccentric, man who lived in Craigentinny House, since demolished, of which the 'marbles' are the only surviving relic. Placed among some of the ornate funerary architecture in the city's cemeteries, this mausoleum would perhaps not look amiss, but here it sticks out like the proverbial sore thumb. This is an object of curiosity, but certainly not one of beauty.

102. PRINCES STREET GARDENS, FLORAL CLOCK, EH1

A popular and unusual attraction in the gardens close to Princes Street itself is the Floral Clock. This dates back to 1903 or 1904, when it was created by the city parks superintendent. The clock has only required two mechanisms over all those

Kilns at Portobello.

years. The display has a different theme every year, and is a complicated work of horticultural art – it consists of 27,000 individual plants. It is good that it is so well appreciated.

103 PRINCES STREET GARDENS, DR THOMAS GUTHRIE STATUE, EH1

Thomas Guthrie (1803–73) was a clergyman and philanthropist best known for his pioneering work with Ragged Schools in Edinburgh. The term 'Ragged Schools' would undoubtedly be *infra dig* in today's supposedly politically correct world. Guthrie's motives were decent and honourable – basic education for the children of the poor and needy. His educational theory, however, was fairly basic. Feed the boys porridge for their physical sustenance, feed them the Bible for their spiritual growth and train them patiently with the skills and knowledge to gain appropriate employment. Girls were to play a subservient role, as benefited their station in life.

The words on the plinth sum Guthrie up succinctly:

An eloquent preacher of the gospel. Founder of the Edinburgh Original Ragged Industrial Schools, and by tongue and pen, the apostle of the movement elsewhere. One of the earliest temperance reformers. A friend of the poor and oppressed.

Born at Brechin, Forfarshire. Minister successively of Arbirlot and of Greyfriars and St John's parish churches and of free St John's Church in this city.

The original Ragged School was sited next to the Camera Obscura Outlook Tower in the Old Town, just below the Castle. It was founded in 1847 and initially housed forty-five of the district's most destitute children. They resided on the site, receiving free victuals (mostly porridge) and lodging. As well as being given a modicum of numeracy, literacy and divinity, the boys were taught to make shoes and clothes and the girls were trained to be 'thrifty wives for working men'. So much for political correctness.

Guthrie is buried in the Grange Cemetery.

104. PRINCES STREET GARDENS, ROSS FOUNTAIN, EH1

Few people can pass a working fountain without giving it at least a second glance. As a child, the author could never pass the Ross Fountain in the west end of the gardens without a second glance. He was drawn inexorably to the ferrous full-breasted Amazons adorning the structure. Mind you, in those days, for a would-be red-blooded eleven-year-old boy like him, there was only the Ross Fountain or the

The Floral Clock.

well-thumbed pages of *Health & Efficiency* with which to acquaint himself with the image of the female breast. All of us boys were tantalised by the curvaceous growths developing on the chests of our female fellow-pupils, but none of us could contemplate a situation where we would actually see one in the flesh, as it were. So we had to make do.

The Ross Fountain now looks pretty innocent to the author's world-weary eye but when it was installed in 1862 (he's not that old), it aroused a hornet's nest of protest about it being offensive and encouraging lewd behaviour. It was paid for by Daniel Ross, a wealthy self-made local gunsmith. He was either a fan of the skills of those who could produce such decorative work in cast iron or he was a fan of erotic statuary, or both.

105. QUEEN MARY'S BATH-HOUSE, ABBEYHILL, EH8

This very odd and venerable-looking little building was part of the complex of buildings making up the Palace of Holyrood House and Holyrood Abbey. It is unlikely to have actually been a bath-house, but it may have been a summer-house – a kind of Scottish gazebo. From the street furniture point of view, its interest lies in the fact that it is still there. Abbeyhill takes a twist to get round it, and it is a miracle that it has not been knocked down for road-widening. After all, the city fathers have had no hesitation in knocking down more august buildings than this simply because they got in the way of the great God, Motor Car.

106. QUEENSBURY HOUSE, CANONGATE, EH8

On the south side, at the foot of the Canongate, stands Queensbury House. Even by Edinburgh standards, this house has had a troubled history. It was built in the early 1680s, and soon after it was completed it was bought by the reclusive 1st Duke of Queensbury. In 1700, his daughter somehow managed to set fire to herself and she received burns severe enough to prove fatal. His successor, the 2nd Duke, was very unpopular with the Edinburgh mob because of his adamant support for the Act of Union with England of 1707. That, for many Scottish people, was too much like sleeping with the enemy.

His son was a lunatic who murdered a young boy who worked in the kitchens of the house. Now, murder was by no means uncommon in the Canongate but this particular murder excited fascination and revulsion equally, because the youth dismembered, roasted and ate as much of the scullion as he could stomach. Its bodily parts having largely been recycled, the soul of the kitchen boy lived on as a ghost, inhabiting those parts of the building that it was most familiar with.

With the reputation of having witnessed such horrors within its portals, Queensberry House was not the easiest of properties to let and it has had a wide

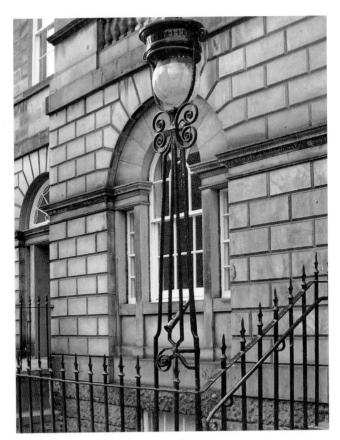

Snuffer and other elegant ironwork, Queen Street, EH2. Without a doubt, the New Town in its early days was one of the most sought-after and fashionable residential districts in Western Europe. Although many of its original houses now contain offices or are let as apartments and flats, the area is still prestigious and a joy to walk around. The builders paid great attention to detail not only with the major items but in minor ones as well and the street frontages show many fine examples of high quality ironwork. This building retains a snuffer for extinguishing the rushlight that would have been carried by a man employed to accompany the residents through the streets during the hours of darkness.

variety of occupants, as well as several spells of being vacant. However, more recently it had an expensive refurbishment and is now part of the complex of buildings making up the Scottish Parliament. Such is the nature of politicians that the witnessing of more skulduggery at Queensberry House is a distinct possibility in the future, although hopefully without the fatal outcomes of the past.

107. RADICAL ROAD, HOLYROOD PARK, EH8

This is actually not a road at all, but a path through the park towards Salisbury Crags from close to Holyrood House, and it was built as a public work to provide employment at a time of economic recession and distress. This in itself was quite radical at the time – the concept of pump-priming the economy not having been invented then – but it gained the name 'Radical' from the fact that the near-destitute labourers employed on the project were thought to be political radicals and supporters of the principles that provoked the early phases of the French Revolution.

108. REDFORD ROAD, COLINTON EH13

Deep in Edinburgh's southern suburbs and on opposite sides of Redford Road, two curiosities are located close to each other. One is a bungalow dwelling displaying what are often called the 'Drummond Scrolls'. These are extraordinarily florid pieces of carved stonework which were brought here when the old Royal Infirmary in Drummond Street was demolished around 1884. Close by is the Covenanters' Monument. Strangely enough, this is also composed of stonework from the same infirmary, but what gives the column its curiosity value is the rather haphazard manner in which the various pieces relate to each other, or, some would say, don't relate. Intended primarily to honour the Covenanters, the Romans, Cromwell (1650) and Charles (1745) are also mentioned in inscriptions at the top of the monument.

109. REGENT ROAD, CALTON, BURNS MEMORIAL, EH1

Scotland is rightly proud of its national bard, Robert Burns (1759–96), a self-taught man of the people. It is tempting to think that some of his popularity is due less to the merit of his literary output than to the fact that he was reassuringly human and simple in his activities and desires. He was an inveterate and successful womaniser and a hard and heavy drinker and, between the two, it is something of a mystery that he ever had the time to put pen to paper. He was also an ardent nationalist. He did not allow success and fame to go to his head and cared little for the trappings and lifestyle that were supposed to accompany his literary eminence.

It is something of an irony, therefore, that the nation chose to commemorate him with such an overblown structure. It was erected in 1830 and designed by Thomas Hamilton, who modelled it loosely on the Choragic Monument of Lysicrates. Those who make the pilgrimage to see it often go away feeling that there is something missing. There is indeed something missing. It was once graced by a statue of Burns himself, the work of the eminent sculptor Flaxman. This was removed and placed in the National Portrait Gallery. The Burns Memorial, which can be approached off Regent Road, is therefore something of an oddity. It is missing a representation of the very person whose life and work it seeks to celebrate. Goodness only knows what Burns himself would have thought of it.

110. RESTALRIG ROAD SOUTH, EH7

At No. 79 Restalrig Road South stands the Bunch of Roses, a suburban pub with an unusual name. It is said that the pub first of all gained this name as a nickname. Close by was the large St Margaret's locomotive shed, and drivers, firemen and other manual grades were coming and going at all times of the day and night. Their

work was physically demanding and many of them liked to refresh themselves with a beer or two after their shift ended. The problem was that some of them also liked to refresh themselves before they started work, but of course a dim view was taken of men reporting for duty after they had been drinking. Some of those who worked inside the shed even liked to nip out for a quick snifter during their shifts. The gaffers also liked to lubricate their throats and so the landlord of the pub – the author does not know what its formal name was – used to put a bunch of roses in the pub window to let the railway workers know when any of the supervisory or management grades were on the premises.

111. RIDDLE'S CLOSE, LAWNMARKET, OLD TOWN, EH1

On the south side of the Lawnmarket, Riddle's Close is a narrow alley giving access to Bailie McMorran's House. This building is easy to recognise because of its external wooden staircase and it was the home of the baillie, the victim of a quite extraordinary murder in 1595. The murder itself took place in High School Yards in the Blackfriars district, close to the Cowgate. What happened was that the boys of the High School were fed up with only having five days of holiday each year. They had voiced their protests on many occasions but without any sympathy, and they had had enough. To make their point, they decided to occupy the school. On 15 September, the rector of the High School, whose name incidentally was a curio in itself – Hercules Rollock – turned up to unlock the school first thing in the morning only to find it had been broken into overnight and occupied by a large number of pupils who were clearly in a determined and truculent mood. Rollock threatened, blustered and begged, but the boys were not for turning and would not come out. Publicly humiliated and muttering imprecations under his breath, Rollock called for assistance from Baillie McMorran, an august and well-known local councillor.

If Rollock thought that the mere appearance of a man of such gravitas as McMorran would make the boys see sense and surrender, he was quickly disabused. Catcalls and jeers, ribald and rude comments poured out of the school as McMorran and his underlings stood expostulating in the yard. The leader of the boys was one William Sinclair, and he managed to shout above the general hubbub that if McMorran did not back off, something unpleasant was likely to happen. Some of the boys in the sit-in were now getting fearful of the punishment the authorities would exact, and it may have been this feeling that caused Sinclair to react by suddenly producing a firearm. With fortuitous accuracy, he shot McMorran in the head, killing him instantly.

The school involved in this unpleasantness catered for the sons of many of Scotland's richest and most influential men. The authorities wanted to inflict the maximum punishment allowable under the law on the trigger-happy Sinclair,

and to teach the other ringleaders a lesson they would never forget. Their dear paters disagreed and real power talked, as it always does. Consequently, the only punishment the boys received was removal from the school and despatch to other academies. However, a scapegoat had to be found and this was the unfortunate Rollock. He got an old-fashioned rollocking, and was then dismissed.

112. ROSEBANK CEMETERY, PILRIG, EH6

Rosebank Cemetery is some distance from most of the famed attractions that draw vast numbers of visitors to Edinburgh. The cemetery contains a memorial to the worst railway accident in British history. This occurred on 22 May 1915 at Quintinshill, not far from Gretna on the Caledonian Railway. No fewer than five trains were involved, but the worst damage was sustained by a special troop train carrying a regiment of the 7th Royal Scots from Larbert, destined for Liverpool. The troop train consisted of old wooden coaches and was 213 yards long. The high-speed impact of the crash reduced it to a mere 67 yards. These wooden coaches were gas-lit, and as red-hot coals from a derailed engine were thrown around violently, some of them landed on the shattered wooden carriages and ignited the gas cylinders, which exploded and turned the wreckage into an inferno. An estimated 227 people died in this disaster, sometimes called the Gretna accident, and approaching 200 were seriously injured. Of the dead, it appears that about 215 of them were members of the Royal Scots.

This horrifying tragedy hit Edinburgh, and Leith in particular, very hard because a very large number of those killed were young men from the area who has just completed their initial combat training and were off to active service, probably in the Dardanelles Campaign. A large number of those killed were interred in a mass grave in Rosebank Cemetery, which contains a memorial to the disaster in the form of a Celtic cross. The author has visited this in many occasions and it never fails to move him.

113. ROSE STREET, EH2

Rose Street is a curious mixture of some shops with eating places and pubs; in many ways, these are rather more interesting than the standard multiple-chain high street shops which line the north side of Princes Street.

Outside one shop selling smokers' requisites, the traditional wooden shop sign of a Native American can be seen. Such 3-D advertisements were once common, but both the signs and the shops whose wares they drew attention to have declined very rapidly in numbers over recent decades as smoking has become demonised.

A rarer survivor on the south side of the street is a hanging sign outside a former outlet belonging to John Menzies, the well-known newsagents. This company

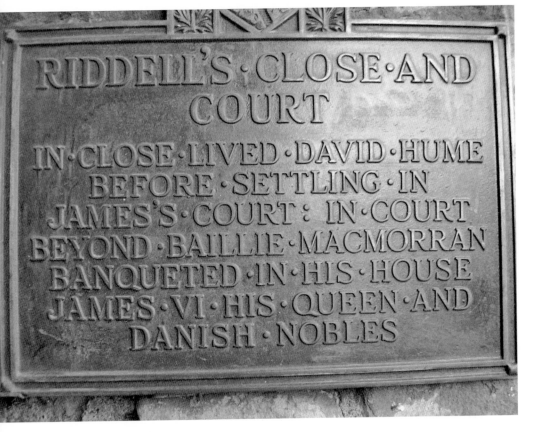

Plaque, Riddle's Close, Old Town.

opened its first branch in Glasgow in 1868 and spread its chain of outlets to cover virtually every town of any size in Scotland, and not a few in England. It also had many bookstalls on railway stations. It sold the retail business in 1998 to WH Smith, which now has a virtual monopoly, but Menzies is still involved in the distribution operations.

114. ROSE STREET, NO. 159, DIRTY DICK'S PUB, EH2

Rose Street, running parallel with George Street and Princes Street in the city centre, once had an awesome reputation because of the large numbers of pubs along its considerable length. Although the number of pubs is now greatly diminished, several survive and staggering down Rose Street and having a pint in each of them is no mean feat. One of these pubs is Dirty Dick's, supposedly named after a local ne'er-do-well who tried to eke out a living by collecting horse droppings and selling them as fertiliser. The frontage sports a rather handsome clock with the legends 'Dirty Dick's' and 'Guinness Time' on the dial and above it is a fairly jovial-looking toucan.

Gretna Memorial, Rosebank
Cemetery.

At one time toucans and Guinness were almost synonymous. In the 1930s, an artist by the name of John Gilroy began to produce humorous advertisements for Guinness which first of all featured a toucan, and went on to include such unlikely creatures as sea lions, ostriches, gnus, lions, crocodiles, tortoises, kangaroos and elephants. Collectively they became known as 'the Guinness Zoo'. A cobra had been considered, but was rejected as too scary. These animals managed to exude a sense of bonhomie, although sometimes they were portrayed in the act of trying to steal the zookeeper's Guinness.

Dorothy L. Sayers (1893–1957), better known for her very fine detective stories, worked as a copywriter for the advertising agency employed by Guinness and she produced this immortal verse to accompany the toucan advert:

> If he can say as you can
> Guinness is good for you
> How grand to be a Toucan
> Just think what Toucan do

Right: Indian shop sign, Rose Street.

Below: Police regulations sign, Rose Street. An interesting juxtaposition of messages.

115. ROYAL MILE, WELLHEADS, EH1

At various points along the Royal Mile, there are small square buildings which give the impression that they might have been water pumps or wells. They are in fact wellheads, and they provided the water supply for the inhabitants of the Old Town from medieval to comparatively recent times.

The Royal Mile is the most obvious tourist trail in Edinburgh and although parts of it are now a honeypot designed to lure the tourists to buy tacky but expensive mock-Scottish paraphernalia of no conceivable use and possessing absolutely no historical authenticity, it is partly redeemed by the fact on damp, misty evenings in November, when relatively few people are about, a wander through a pend and down a wynd can still provide at least some sense of the area's shady and sinister past. This feeling was expressed by H. V. Morton (1892–1979), the prolific travel writer, with his customary felicity when he commented in his book *In Search of Scotland*: 'Here are the ghosts of Edinburgh, here in these old stone courtyards, in these dim wynds and closes where pale, insignificant lamps hang above flights of grey stairs, the mighty history of this city stirs a little in its sleep. It is grey, sinister, medieval.'

116. ROYAL OBSERVATORY, BLACKFORD HILL, EH9

The serious study of astronomy in Edinburgh dates back to the seventeenth century. In the heyday of the Enlightenment, in the second half of the eighteenth century, the Astronomical Institute of Edinburgh was established and in 1818 it opened an observatory on Calton Hill, replacing a much earlier one. When George IV visited the city in 1822, he gave the institute an official stamp of approval by calling this building the Royal Observatory.

Not for nothing was Edinburgh called 'Auld Reekie'. Even state-of-the-art technology could not counter the effect of aerial pollution on the observatory's functions, and in the late 1880s it was decided that a change of location was necessary. A decision was eventually made to move the Royal Observatory to Blackford Hill. The new observatory was inaugurated in 1896. The result was the eye-catching collection of buildings visible across much of south Edinburgh, including the almost-iconic green copper turrets and splendid stonework.

117. ST ANDREW SQUARE, NEW TOWN, MELVILLE MONUMENT, EH2

An enormous stone column dominates St Andrew Square at the east end of George Street, and atop this column is a giant statue of Henry Dundas (1724–1811). He became the 1st Viscount Melville and was a ruthless, self-serving political opportunist of the first rank. Power-mad and with an ego as big as this posthumous

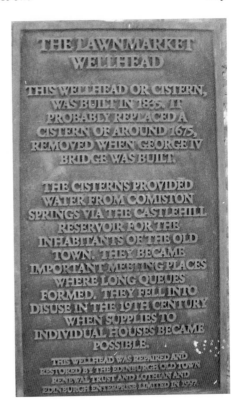

THE LAWNMARKET
WELLHEAD

THIS WELLHEAD OR CISTERN,
WAS BUILT IN 1835. IT
PROBABLY REPLACED A
CISTERN OF AROUND 1675,
REMOVED WHEN GEORGE IV
BRIDGE WAS BUILT.

THE CISTERNS PROVIDED
WATER FROM COMISTON
SPRINGS VIA THE CASTLEHILL
RESERVOIR FOR THE
INHABITANTS OF THE OLD
TOWN. THEY BECAME
IMPORTANT MEETING PLACES
WHERE LONG QUEUES
FORMED. THEY FELL INTO
DISUSE IN THE 19TH CENTURY
WHEN SUPPLIES TO
INDIVIDUAL HOUSES BECAME
POSSIBLE.

THIS WELLHEAD WAS REPAIRED AND
RESTORED BY THE EDINBURGH OLD TOWN
RENEWAL TRUST AND LOTHIAN AND
EDINBURGH ENTERPRISE LIMITED IN 1997.

Plaque on the wellhead in Lawnmarket, Old Town.

memorial, his influence in Scotland was such that he was unofficially known as 'Henry the Ninth'. If anything, his influence in Westminster was even greater. It was not a force for good, however, and his peculation of public funds eventually led to him being impeached. He managed to escape the full implications of his activity by pleading guilty to the lesser charge of negligence, and was promptly restored to public office. His reputation had suffered, however, and his star was on the wane.

At first sight it is a complete mystery as to why this totally unprincipled politician should have been remembered in this way, but then of course it would be naïve to think that only those whose works had benefited others are candidates for public memorials. Shakespeare wrote: 'The evil that men do lives after them; the good is oft interred with their bones.' Dundas was mortal like all of us. Unlike others, however, he probably never did any good while alive, but the memory of this unattractive reprobate lives on in the form of the Melville Monument.

118. ST ANDREW'S HOUSE, REGENT ROAD, CALTON, EH1

If you stand opposite St Andrew's House, where a path of steps leads up to Calton Hill, tucked away inconspicuously is the Singers' Memorial. Three profiles

are shown on a plaque surrounded by wreaths and accompanied by the words 'In Memoriam'. Those portrayed are John Wilson, John Templeton and David Kennedy. The three of them were all local men of the nineteenth century who gained fame by carving out successful careers for themselves as singers, and whose reputation extended beyond the shores of Britain.

119. ST BERNARD'S WELL, WATER OF LEITH WALKWAY, EH2

The well to be seen today was built in 1789 to provide a fount for spring water with a sulphurous content thought to be efficacious for a variety of physical conditions. Mineral springs have, since time immemorial, been ascribed as having miraculous health-giving properties, particularly by the genuinely afflicted or by those who make a lifestyle out of hypochondria. Additionally, springs and wells have often had sacred associations and, especially in the eighteenth and nineteenth centuries, there was a fashion for building wellheads in the form of small temples. The existence of this mineral water was discovered around 1760 by Lord Gardenstone, who claimed that they had had a marvellously purgative effect on him. Gardenstone was a noted eccentric who probably needed a thorough purge – he was a bachelor who found it comforting to sleep with a number of pigs in his bedroom.

St Bernard's Well, which was designed by Alexander Nasmyth, taking a day off from his normal occupation of landscape painting, consists of ten Doric columns, a carved entablature and a statue of Hygeia, who was the Goddess of Health in Greek mythology. The statue to be seen today is a replacement for the original.

The water still flows, but is not generally available for sampling. The well is a curious but attractive interpolation along the route of this walkway, a delightfully peaceful and seemingly rural route passing through densely populated parts of the city.

120. ST CUTHBERT'S KIRKYARD, LOTHIAN ROAD, EH1

St Cuthbert's was subjected to so much attention by the 'resurrectionists' that the authorities were forced to raise its walls to a full eight feet. Even that did not stop them. Near the main door of the church is a monument to John Napier (1550–1617). He was something of a renaissance man, an inventive genius with wide-ranging interests. However, he would have been cursed by generation after generation of school children had they known, because it was he who invented logarithms, a development of huge benefit to mankind. As a schoolboy, the author was presented with densely packed and totally incomprehensible tables of logarithms to which he was supposed to refer in order to complete mathematical

Water of Leith Walkway.

tasks of seemingly monumental pointlessness. This experience only served to convince him that he was an intellectual no-hoper. Nothing has happened since to disabuse him of this self-perception.

Not far from the Lothian Road entrance, and close to where King's Stables Road skirts the cemetery, can be found the burial place of Thomas De Quincey (1785–1859). He was born in Manchester in 1785, and was showing rebellious, or at least independent, tendencies when only a teenager. Although he was happily married and the father of eight children, he lived apart from his family because, according to him, they made too much noise. He was a heavy drinker but more notorious for his *Confessions of an English Opium-Eater*, in which he discusses his relationship with that narcotic. A man of letters, he never threw any paperwork away and when his quarters became too crowded for him to move, he simply took larger accommodation nearby. He was almost morbidly interested in murders and murder trials, and this was reflected in his essay *On Murder Considered as one of the Fine Arts*.

He spent much of his life in Edinburgh engaged in literary work and died at No. 42 Lothian Street.

121. SCIENNES, EH9

Sciennes is a somewhat forgotten quarter, rather off the main tourist routes and having something of a cosmopolitan character. Its most prominent building is probably the Royal Hospital for Sick Children in Sciennes Road. Sylvan Place is a turning off this road and down a small wynd off Sylvan Place. A wall at the back of Sylvan House displays a plaque to the effect that Joseph Black lived there. Black (1728–99) was born at Bordeaux and became a research chemist. He discovered carbon dioxide and was active in many industrial enterprises, but he was also an outstanding teacher and, among other posts, he held the Chair of Medicine and Chemistry at the university.

122. SCIENNES HOUSE PLACE, EH9

In this obscure side street, at No. 7, a plaque can be seen recording the fact that it was nearby that Robert Burns and the young Walter Scott had their first and apparently only meeting. Almost opposite is a Jewish Cemetery, although it is not generally open to the public. This acted as a burial ground from 1816 to the 1870s and is a reminder that there has long been a strong Jewish presence in the Newington district. Also to be seen in this street is a rather cute little building on the north side, which was once a fire station housing two appliances.

123. SCOTT MONUMENT, PRINCES STREET, EH1

This is surely one of the most monstrous pieces of street furniture ever created. Such is the weight and visual impact of this structure that it is easy to overlook the actual statue of Sir Walter Scott in white marble nestling near its base. Sixty-four smaller statues encrust the monument, and these represent characters from his novels. As so often happened with public projects in those days, a competition was held to choose the best design and this was won, after a recount, by a hitherto unknown architect called George Meikle Kemp. The monument was completed in 1846, by which time Kemp was dead – he had accidentally walked into the Union Canal. This was a shame, because it has deprived us of what could have been a glorious heritage of equally eccentric erections. It has always elicited mixed responses. Dickens likened it to the top of a Gothic steeple which had been cut off and planted in the ground. It has also been called a 'Gothic Rocket'. Its Gothic detail – it had to be Gothic, because that was the mood of imaginative romance associated with Scott's novels – is architecturally correct. Princes Street would seem bare without the monument.

Born in College Wynd, Edinburgh, in 1771 and dying in 1832, Scott was a poet and an exceptionally prolific and widely read novelist. A great student of Scottish border legends and ballads, his tales are best categorised as 'historical novels', although they bear about as much resemblance to actual historical events as do

the plays of Shakespeare. Nevertheless, they are full of tales of derring-do, mystery and romance and they sold like hot cakes in the nineteenth century. Scott's work did much to encourage a rather faux, over-romanticised view of Scottish history and heritage, but it also contributed significantly to a sense of nationalism and pride and helped to generate tourism in Victorian times. His writings are visited far less in more recent times, but the effects of his influence unquestionably help to bring in substantial amounts of money every year for the Scottish economy.

Scott never enjoyed the best of health, was notoriously absent-minded, sometimes worked under the influence of laudanum (partly at least to relieve pain), was usually financially embarrassed despite his output selling so well – he made a number of serious financial misjudgements – and he loved animals. He had a pony called Earwig.

124. SCOTTISH WHISKY HERITAGE CENTRE, NO. 345 CASTLEHILL, EH1

You can't blame them for having a business like this in a part of Edinburgh heaving with tourists, all eager to buy into the (largely faux) Scottish experience. Some of the stuff on sale in the Royal Mile may be tasteless tack, but there is nothing tasteless about Scottish whisky. It is deservedly famous the world over. Here, you can drink in the history of centuries of whisky production in Scotland and the drink the result. The word 'whisky' is Celtic and comes from the Gaelic *uisge-beatha*, which means the water of life. It is commonly assumed that whisky is a product of the Highlands, but Edinburgh also has a history of whisky-distilling – both legal and quite possibly illegal.

The building in which the centre is housed was once a school for children of the working classes, and its former use is indicated by an inconspicuous roundel, depicting a child apparently being instructed by a female figure who is pursuing this worthy activity while apparently, and rather oddly, wearing a crown.

Sciennes House Place Tablet.

The old fire station, Sciennes House Place.

125. SPRING VALLEY TERRACE, EH10

Nos 43 and 45 Spring Valley Terrace are part of a block of tenements, and a stone plaque built into the fabric of these buildings records the fact that the mansion known as Spring Villa used to be close by. It was demolished in 1907.

Spring Valley Terrace can be reached from Morningside Road via Cuddy Lane. The name suggests the former rural nature of this area, 'cuddy' being a dialect word for horse or donkey. Given that it is in the middle of a bustling and densely built-up urban district, Cuddy Lane is extraordinarily rural, having a number of tiny one-storied cottages totally out of scale with the tall and rather stark blocks of tenements so close by on Morningside Road. Other buildings from the old rural village of Morningside can be discovered during a walk around the streets of this district.

Just around the corner from Cuddy Lane, at No. 200 Morningside Road, a plaque can be seen high up on the frontage of the tenement block. This records

the fact that a small mansion called Morningside House formerly stood on the site. A rich seam of inspiration would be available for the author who decided to write a book on the great eccentrics of Edinburgh. Morningside House was the residence of one such man who could proudly take a place in any pantheon of oddballs. He was Lord Gardenstone, a man with a great affection for pigs. His favourite pig was thoroughly domesticated and was placed in his master's bed to warm it up on a cold winter's night. When Gardenstone himself climbed into the bed, the pig was then dressed in Gardenstone's clothes so that they would be nicely warmed-up by the morning. Other pigs used to share their master's night quarters.

126. STOCKBRIDGE, EH3 AND EH4

This fashionable and trendy urban village possesses yet another of Edinburgh's landmark clocks, this time one on a rather odd little steeple on what used to be the Edinburgh Savings Bank in Deanhaugh Street. It stands by the bridge over the Water of Leith, on which there are plaques giving the history of the structure.

In Saxe Coburg Street stands Stockbridge parish church, which looks like nothing so much as a small town hall, topped as it is by a tower (with another clock) of a size disproportionate to the rest of the building.

In Henderson Row, the frontage of the Edinburgh Academy can be seen. The sharp-eyed will notice a phrase in Greek lettering below the pediment. Greek and Latin scholars are a bit thin on the ground these days, but the author can coolly inform his readers that this is the school motto. It declares, 'Education is the mother of both Wisdom and Virtue.' He knows that because he has had it translated for him, and not because he himself is a scholar of the classics.

127. THE BORE STONE, MORNINGSIDE ROAD, EH10

On the east side of Morningside Road by the parish church, the Bore Stone can be found. Attached to the stone is a metal plaque with the following wording:

THE BORE STONE

In which the Royal Standard was last pitched for the muster of the Scottish Army on the Borough Muir before the Battle of Flodden 1513.

It long lay in the adjoining field, was then built into the wall near this spot and finally placed here by Sir John Stuart Forbes of Pitsligo, Bart, 1852.

Cottages, Cuddy Lane, Morningside.

> Highest and midmost was descried
> The royal banner, floating wide:
> The Staff, a pine tree strong and straight:
> Pitched deeply in a massive stone
> Which still in memory is shown,
> Yet bent beneath the Standard's weight.

This is all good, romantic stuff, but whether this stone played a martial role before the disaster of Flodden Field is disputed by some. It is possible that Sir Walter Scott was the originator of the notion of The Bore Stone's role in history, and in fact the stone's original purpose may have been some kind of boundary marker.

128. THE COLONIES, GLENOGLE ROAD, STOCKBRIDGE, EH2

The Edinburgh Co-operative Building Company was established in 1861 by a number of building workers as the result of them having been locked-out by their employees for three months, a situation causing much financial hardship. They hit on the idea of building houses to be let for rents or sold at prices that working people could afford. They were successful, and by 1911 this example of workers' self-organisation had built over 2,300 dwellings, about 5 per cent of all the houses constructed in Edinburgh in that period. As well as encouraging 'respectable' working people, especially but by no means exclusively those in the building trades, to take out cheap mortgages and to become owner-occupiers of well-built homes in developments where there would be a first-class community spirit, the ECBC was also concerned about tackling the disgraceful housing conditions in which so many of Edinburgh's working class lived, especially in the Old Town.

The site chosen was on the floodplain of the Water of Leith, which made it unattractive to other developers. The river itself

> ... not only receives the sewage matter and refuse of probably 100,000 but is also made the receptacle of all the horrible abominations which leak and ooze out of the diverse glue-works, paper-mills, chemical works, and gas works ... and from a gigantic distillery, which discharges enormous quantities of hot and acrid wash into its already polluted channel.

Not surprisingly, the land was cheap and it was eagerly snapped up by the ECBC. The dwellings were solidly built and, unlike the tenements, each flat had its own front door rather than a communal front door and stair. By the standards of high-density housing of the time, The Colonies were very advanced. Further developments were sponsored by the ECBC, some of them in more traditional tenement or terrace form but others such as those off London Road, Abbeyhill, being rather more reminiscent of The Colonies. These developed a very strong sense of community and of mutual support in difficult times or collective celebration when there was something to celebrate.

The Stockbridge Colonies of eleven parallel terraces have survived virtually intact and, curiously for such an urban phenomenon, have acquired a distinctly rural or village-like character – *rus in urbe*, as it were. Closer examination of them will reward the seeker after curious unconsidered trifles. Sadly, however, the concept of workers' self-help which underpinned The Colonies has given way to market forces and materialism, and they are now highly desirable residences with price tags to match.

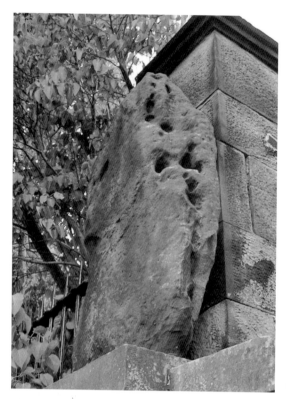

The Bore Stone.

129. THE INNOCENT RAILWAY, EH8

The first railway station in Edinburgh was in the St Leonard's district, just at the western edge of Holyrood Park. It was the terminus of a very steeply graded branch line from Niddrie which went past Duddingston, and it was built by the Edinburgh & Dalkeith Railway. It opened at the very early date of 1831. The purpose of the line was to bring Lothian coal to the city. When it opened, it was built to a gauge of 4 feet 6 inches, which was common in the early days of Scottish railways. The trains, which would have consisted of just a couple of small wagons, were hauled by horses and, on the steepest section, by a steam-powered cable. Steam locomotives eventually took over from horsepower and cable, and the track was relaid as standard gauge. The gradient of 1 in 30 always provided the locomotives with a severe challenge.

As it approached the St Leonard's terminus, the line went through a gas-lit tunnel. This tunnel still exists, although not of course gas-lit, and it is now part of a cycleway and walkway going through to the Craigmillar district in the southern suburbs. A walk through this tunnel, the northern end of which is just above Holyrood Park Road, is a slightly strange and eerie experience. The tunnel must certainly have tested the mettle of the men on the footplate as their engines puffed slowly uphill through its narrow confines. It is 572 yards long.

The Colonies, Stockbridge.

The St Leonard's branch prospered, especially by bringing coal for domestic use and for the various industries such as the breweries close to St Leonard's in the Dumbiedykes and Holyrood parts of the city. A sporadic passenger service operated and occasionally a seaside special train was put on – from St Leonard's to Portobello and back.

The line was known to all and sundry as 'the Innocent Railway' because, or so it was said, no one operating the line or travelling on it was ever injured or killed. In fact, this claim was untrue and we would have to look elsewhere and dig deeper to find the real explanation. The passenger trains that ran on the line were not noted for their speed, and stories abounded of passengers stepping off the train to gather daisies to make a chain or to do a spot of blackberrying before catching the train up and re-boarding.

Incidentally, the building at the St Leonard's end which calls itself 'the engine shed' was actually a shed serving the goods, coal and merchandise depot at that point and did not house locomotives.

The Innocent
Railway.

130. THE MEADOWS, EH3

The much-loved Meadows stands on the site of the former South, or Burgh, Loch,
a large sheet of water which separated outer areas of Edinburgh such as Sciennes
and Bruntsfield from the Old Town. The present Melville Drive roughly marks
the southern extent of the loch. Although the loch was fed by a small stream, long
since hidden from sight, it was not particularly fresh-looking and indeed in dry
summers, the western part became nothing more than a swamp. It is therefore
disconcerting in retrospect to learn that the water was extensively tapped by a
number of breweries. In fairness, of course, the water extracted from the loch
would have been boiled in the course of the brewing process. However, it is hard
not to think that the local brews may have had a flavour or tang very much their
own. The Burgh Loch started to be drained in the seventeenth century, whereupon
its former site became and continues to be a much-loved and intensively-used large
green space, close to the centre of Edinburgh.

At the eastern entrance to the Meadows, on Melville Drive, there are two
stone columns topped by a lion and a unicorn. These were a gift to the city
by Thomas Nelson & Co., the well-known firm of printers and publishers, by

The north end of the
Innocent Railway tunnel.

way of thanking the authorities for allowing them temporarily to move their operations to the Meadows after they had experienced a serious fire in their premises nearby.

The western end of the Meadows also has two tall pillars, and these commemorate the fact that the Edinburgh International Exhibition was held here in 1886. These pillars provide more information than their counterparts to the east. They are composed of stone from several sources and the names of the quarries of origin are incised in the stonework. There are also many heraldic devices on display. Close by is an octagonal sundial, and it commemorates the opening of the exhibition by Prince Albert Victor. He was the eldest son of the future Edward VII and was a dissipated young man who died prematurely at the age of twenty-eight.

On Melville Drive there is another memento of the Exhibition. This is the well-known whale-jawbone arch which stands at the southern end of Jawbone Walk. A jawbone is a fairly unusual item of street furniture, but there are a couple of other towns in the UK which display similar items – not to everyone's taste.

Column commemorating the
Edinburgh Exhibition of 1886.

131. THE *SCOTSMAN* BUILDING, NORTH BRIDGE, EH1

No one would call the former *Scotsman* building on the west side of North Bridge understated. Anybody crossing that bridge from the Princes Street direction cannot miss the building or the eye-catching carved panel bearing the legend 'The *Scotsman*' on its northern gable.

 The Scotsman's origins date back to 1817. It started as a weekly newspaper, published on Saturday and costing ten pence, of which four pence went in tax. This made it and all other stamped newspapers expensive, and the high price inevitably limited the circulation. The paper favoured the Liberal Party and it supported such causes as parliamentary reform and Catholic emancipation. Soon a Wednesday edition was being published, but sales greatly improved after 1855, when advertisement and newspaper stamp duty were abolished. For a period it was known as *The Daily Scotsman*, cost one penny and sold 6,000 copies. In 1865, it had reverted to *The Scotsman* and had a daily circulation of about 17,000.

 The Scotsman was always an Edinburgh paper, starting in the High Street, moving to Cockburn Street and then to the site at North Bridge around 1900.

Jawbone Arch, Melville Drive.

This site was carefully chosen for its proximity to Waverley station. The paper owed much of its success to making full use of the developing railway system, which could transport freshly printed copies at what was then high speed right across Scotland. A special fast early morning service to Glasgow allowed *The Scotsman* to be on sale in that city just 70 minutes after it had appeared on the streets of Edinburgh.

The magnificent new offices on the North Bridge were designed to impress and dominate their surroundings, being lavishly fitted out and furnished. In the 1960s, daily circulation was around 70,000. The paper has undergone changes in ownership, and in the 1990s it moved to a new state-of-the-art site at Holyrood, the North Bridge building no longer a suitable location for the production of a modern newspaper. The building, which has deliberately retained its *Scotsman* identity, is now a luxury hotel.

The Scotsman, North Bridge.

132. THE VENNEL, GRASSMARKET, OLD TOWN, EH3

The Vennel is a very steep street in the form of steps leading up in a southerly direction from where the West Port opens into the Grassmarket. Here are surviving fragments of Edinburgh's medieval wall. Another section can be found in the Pleasance/Drummond Street area of EH8. Walls like these would not have been able to withstand any serious sustained assault, but they gave some sense of security to the folk living inside them. They were penetrated via gates, and that enabled the town authorities to control who came and went and to extract tolls from them. The existence of these walls and the precipitous site on which the Old Town was built meant that overcrowding became steadily worse and there was little option but to build upwards, and so Edinburgh had what in effect were medieval high rise buildings.

133. THE VOLUNTEER ARMS, MORNINGSIDE ROAD, EH10

This street-corner pub on the east side of Morningside Road is one of the relatively small number of pubs in this part of the city. Its origins go back two centuries and more, when it acted as a howff for carters, waggoners and others plying the roads

The Flodden Wall in The Vennel, EH3.

from the direction of Peebles and Biggar into Edinburgh. It also attracted men of the local militia, the Edinburgh Volunteers, hence its official name. They would engage in training on open space nearby and resort to the pub for essential refreshment afterwards, often leaving the premises in a state of such advanced inebriation that they would have been rendered totally incapable in the event of any immediate military emergency. However, most people know the pub as The Canny Man's. No one is quite sure why it gained this nickname. It may be that a well-known former landlord by the name of James Kerr had a reputation for his canny business sense, or it may suggest that those who patronised the establishment were canny, knowing a good drinking place when they found it. It has an interesting pub sign and some rather eccentric features inside, and should on no account be missed by those fancying a beer when in the Morningside district.

134. THE WITCHERY, NO. 352 CASTLEHILL, EH1

Turning in someone and accusing them of witchcraft made a lot of sense during the period when the persecution of witches or, shall we say, of people suspected of such activity, was at its height. It made real sense if it was someone against whom the person held a grudge or to whom, for example, they owed money. A new career

opportunity opened up for totally unscrupulous and ruthless bullies who got paid for 'proving' that individuals or, sometimes, whole groups of people had dabbled in the black arts. Between the late fifteenth and the early eighteenth centuries, several hundred people alleged to have been witches were burnt at the stake close to the gates of Edinburgh Castle.

The Royal Mile is of course a major tourist trap, and The Witchery restaurant takes advantage of the gory history of its surroundings by displaying a large and colourful sign to attract custom. This mock-heraldic sign has motifs indicative of the sufferings of the victims of a mass hysteria of which all those responsible should have been totally ashamed.

135. TOLLCROSS CLOCK, EH3

Tollcross is not a part of Edinburgh in which to tarry, largely because of the sheer bedlam created by the ceaseless traffic, and also because of the ugliness of the place. It is a busy road intersection, but it does possess one feature which is almost an Edinburgh icon and that is its clock. We live in a world in which almost our entire existence is determined by time. How often must the commuter on the bus or the more foolish one trying to make his way by car through the permanent pandemonium that is Edinburgh's road traffic have glanced at this clock and started preparing his excuses for why he or she was late for work.

136. TWEEDDALE COURT, HIGH STREET, OLD TOWN, EH1

At No. 14, on the south side of the High Street, stands Tweeddale Court. If you pass through the entrance, a small shed with slatted wooden doors will be seen. This is thought by some to be the last remaining sedan-chair store left in the city. It has to be said that this modest little shed does not really look as if it ever had this function.

Nevertheless, we know that sedan chairs were in very extensive use in Edinburgh. These conveyances obtained their name from the town of Sedan in France where they were first used, and they made their debut in England in 1581. They were unpopular at first because they were thought to be demeaning for the chairmen, who were reduced to beasts of burden. However, opinion changed and they came to be accepted, first being used in Edinburgh in 1687. For those who could afford to hire one or the smaller number who actually owned them, sedan chairs provided a handy way of moving around the city, avoiding the filth which covered the streets while also being protected from the elements. Better than a door-to-door service, they could actually be manoeuvred into and out of those premises that had large enough doors. They were cheaper than hackney coaches and were particularly suited to the Old Town of Edinburgh, being able to enter the wynds and closes that horse-drawn conveyances could not penetrate. They operated twenty-four hours

Did this shed ever house sedan chairs?

a day and had regulated fares and codes of conduct, but chairmen were generally thought of as being a truculent group. They often worked under the influence of drink and if the two chairmen could not co-ordinate their movement, the occupant of the chair could be in for a rough ride. The men could also have great difficulty avoiding falling over on wet or icy setts, and on the steep gradients so common in this part of the city. The Tron Kirk was the main base from which they plied for hire. Their use had died out in Edinburgh by 1850.

137. UNIVERSITY BUILDINGS, SOUTH BRIDGE, EH1

The buildings of the University of Edinburgh, which are surrounded by Chambers Street on the north, College Street on the west and south, and South Bridge on the east, stand on the site of one of the most dramatic events in Edinburgh's long history of violence. Part of the site of what is now called Old College was occupied by a sizeable house called Kirk O'Field. In 1567 its occupant was Henry Stuart,

Lord Darnley, the wastrel husband of Mary, Queen of Scots. Darnley was a vapid and hedonistic dimwit who married Mary to advance his craving for power. The couple did not take long to become disillusioned with the marriage and during one of their periodic fallings-out, it was found expedient for him to lodge some way away from Holyrood Palace, at Kirk O'Field. At two in the morning of 10 April 1567, an enormous explosion rent the air and totally demolished the house. The body of Darnley was found close by. Although he had been strangled, he was otherwise unmarked and it seems as if he must have left the building before the explosion actually occurred. These are the bare facts.

The truth about the assassination has never been established. Darnley had many enemies, including the Earl of Bothwell, with whom Mary was becoming increasingly intimate and whom she married just three months later. Bothwell, who was every bit Darnley's equal for ambition and lack of principle but greatly superior in intelligence and resourcefulness, had every reason to wish Darnley dead. Mary herself, increasingly disenchanted with Darnley and obsessed by Bothwell, could be said to have had a motive. On occasion, Mary stopped overnight at Kirk O'Field, which raises the possibility that someone hoped to assassinate both Darnley and the Queen but got the timing wrong.

138. WEST PORT, EH1

West Port descends quite steeply to the Grassmarket. At No. 64, which is Cordiners Land, a ceramic wall plaque displays the words, 'Love God above all and your neighbours as yourself.' 'Cordiners' is a variation on cordwainers. They were workers who fashioned shoes, bottles and other objects out of leather. It would not have been surprising to find such workers in this vicinity because livestock used to be herded down West Port to the Grassmarket, where the animals were slaughtered. West Port was notorious because Messrs Burke and Hare, the notorious mass murderers, lodged there for a time in the 1820s.

139. WHITE HART INN, GRASSMARKET, EH1

This old and famous inn has a prominent position in the Grassmarket. Given the sinister events which have taken place in the Grassmarket, the White Hart must have seen more than its share of skulduggery. Note the attractive sign. A close examination of the façade of the pub, and especially of the stonework around the sign, may reveal signs of the damage caused by flying shrapnel when a bomb dropped by a German Zeppelin fell close to the front of the pub.

POSTSCRIPT

A very prominent item of street furniture has made its reappearance in Edinburgh – tramway track. It is impossible to visit Edinburgh, or at least Princes Street, and not be aware of the fact. Actually, long before any track was laid, the coming of the tram was almost universally denounced because of the chaos created by its construction in Princes Street and elsewhere as the result of traffic diversions.

At present one line is envisaged, running from the airport via Princes Street to Leith, with extensions possible should this route prove successful. It seems to be the experience elsewhere of new light rail systems in the UK that they are roundly condemned and cursed at the planning and constructional stages, but soon after they have started operating everyone starts saying what fun and how beneficial they are, and why did they have to wait so long for the thing to be built in the first place?

This project has been beset with financial, political, legal and contractual problems, and the cost has risen by the minute. Originally intended to be opened in 2011, slippage is occurring and 2014 seems more possible, certainly for the route to be opened throughout.

For the purposes of this book, Princes Street now has tram tracks once more, along with traction poles to support the overhead catenary and a piquant new piece of street furniture – an actual tram, or is it a mock-up? This has been parked for some time near the Scott Memorial so that locals and visitors can get an idea of what to expect when (or if?) the trams ever actually start running. Passengers will buy their tickets at machines in the street so, if and when the system starts operating, these devices will spring up like mushrooms along the route.

The author's cup will be full when he sees trams running through Edinburgh's streets once more. He thinks it's a great shame that they won't be double-deckers, but he has been assured that they will be painted madder and white – the only possible livery for an Edinburgh tram.

LOCATIONS OF PLACES MENTIONED

EH1: 6, 19, 20, 23, 24, 25, 32, 45, 51, 62, 64, 65, 69, 73, 77, 78, 81, 90, 95, 96, 97, 98, 102, 103, 104, 109, 111, 115, 118, 120, 123, 124, 131, 134, 136, 137, 138, 139

EH2: 2, 15, 29, 52, 53, 55, 113, 114, 117, 119, 128

EH3: 7, 14, 50, 66, 71, 130, 132, 135

EH4: 13, 37, 38, 40, 75, 126

EH6: 26, 27, 88, 112

EH7: 17, 48, 72, 79, 93, 101, 110

EH8: 4, 10, 21, 22, 42, 43, 54, 58, 68, 87, 91, 94, 105, 106, 107, 129

EH9: 1, 18, 33, 44, 59, 60, 61, 74, 83, 86, 89, 92, 116, 121, 122

EH10: 3, 8, 11, 12, 16, 28, 30, 31, 41, 46, 70, 74, 84, 85, 125, 127, 133

EH11: 82

EH12: 35, 39, 47

EH13: 9, 34, 108

EH14: 36

EH15: 100

EH16: 5, 67

EH17: 56, 57, 76

EH21: 49

Edinburgh Murders & Misdemeanours

David Brandon & Alan Brooke

ISBN 978 1 84868 173 6

128 pages, 40 b&w illustrations

ALSO AVAILABLE FROM AMBERLEY PUBLISHING

HELEN COOK

ST ANDREWS

THROUGH TIME

St Andrews Through Time
Helen Cook

ISBN 978 1 84868 541 3
96 pages, full colour throughout

Available from all good bookshops or order direct
from our website www.amberleybooks.com